HIDDEN HISTORY
of
NASHVILLE

D1637294

HIDDEN
HISTORY
of
NASHVILLE

GEORGE R. ZEPP

THE
History
PRESS

Published by The History Press
Charleston, SC 29403
www.historypress.net

First published 2009
Second printing 2009
Third printing 2010
Fourth printing 2011
Fifth printing 2012
Sixth printing 2012
Seventh printing 2013

Manufactured in the United States

ISBN 978.1.59629.792.0

Library of Congress Cataloging-in-Publication Data

Zepp, George R.
Hidden history of Nashville / George R. Zepp.
p. cm.
Includes bibliographical references.
ISBN 978-1-59629-792-0
1. Nashville (Tenn.)--History. 2. Nashville (Tenn.)--Social life and customs. 3. Nashville (Tenn.)--Biography. I. Title.
F444.N24Z47 2009
976.8'55--dc22
2009035770

Contents

CONTENTS

CONTENTS

PREFACE

The weekly newspaper column "Learn Nashville" in *The Tennessean* began in April 2002 as something of an experiment. What few seemed to recognize—including the columnist—was how hungry Nashvillians were to hear bits of their own story—from the distant past or recent decades, it didn't matter. Questions and suggestions for topics rolled in steadily from readers. A backlog developed quickly. It is still being drawn upon from time to time in 2009, but new ideas are always welcomed.

With about three hundred subjects covered already, the well has not run dry. Nashville's unique people, places and things continue to fascinate many of us well into the twenty-first century.

This book is the first attempt to collect some of the columns in a different form, with variety as the theme. "Learn Nashville" has included an effort to revive stories not frequently told elsewhere, as well as an attempt to get to the bottom of some of the well-known myths surrounding the city. Among them is the Cascade Plunge swimming pool's razor-blades-on-the-slide rumor, a missing shrunken human head and a world-famous ventriloquist's one-time Nashville protégée.

The serious and important have always been mixed with the not-so serious and barely important. If a favorite topic is missing here, it must regrettably await demand for a sequel.

Several people have written to say that they clip "Learn Nashville" for pasting into scrapbooks for their grandchildren. One couple from Alabama said that they use it to plan frequent what-to-see-in-Nashville trips. The

column represents the desire to pass on experiences, memories and the continuity of life in Tennessee's state capital, Music City.

Nashville is blessed with gifted historians and scores of others interested in its past, as well as its future. Many of the diligent researchers/writers and their works can be found in the Reading List at the back of this volume. All are worth a look.

Those interested in their own investigations as history detectives would be well served to visit the Metro Archives in Green Hills and the Nashville Room of the downtown Nashville Public Library. The staffs of both go out of their way to be helpful daily. More in-depth research is always possible at the Tennessee State Library and Archives, where admission cards and parking outside (if you're lucky) are both free, as is expert assistance.

This column has relied heavily on endlessly fascinating newspaper files, of both *The Tennessean* and the former *Nashville Banner*. Microfilm of newspapers over the past centuries can often reveal a detailed early draft of history as it happened. Puzzles are often solved there.

The *Tennessee Historical Quarterly*, issued by the Tennessee Historical Society, is also an excellent reference, with in-depth information going back many years. The Jewish Federation of Nashville Archives is another handy source of well-maintained records.

Special thanks are due to Meg Downey, managing editor of *The Tennessean*, for her support of the column and this book, and Frank Sutherland, now retired as the paper's editor, who came up with the original idea and name for the column. Also offering valuable assistance and encouragement have been talented *Tennessean* editors, both present and past—including Ellen Margulies, Jerry Manley, Cindy Smith, Ricky Young, Thomas Goldsmith and David Green—as well as everyone on the newspaper's Copy Desk, important, if often unappreciated, sentinels in the battle against confusion and errors. May they all prosper.

TRUE TALL TALES

Coffee, Cave and Curse

MAXWELL HOUSE COFFEE, "GOOD TO THE LAST DROP"

One of the Roosevelts, when president of the United States, made a remark while dining at one of Nashville's hotels, "Good to the Last Drop," which a coffee company (Maxwell House) used for its slogan. Which Roosevelt and which hotel?

—Page Cummins, Chula Vista, California

You are not alone in being captivated by Teddy Roosevelt's 1907 visit to Nashville and the presidential coffee endorsement attributed to him for nearly a century. The coffee blend got its start thanks to Nashvillian Joel Owsley Cheek (1852–1935) in 1892 and was, in fact, named for the renowned Maxwell House Hotel at Fourth Avenue and Church Street in downtown Nashville, where it was first served at Cheek's urging.

However, Roosevelt's praise of the blend was supposed to have come while he was visiting the Hermitage, home of President Jackson, as a guest of the Ladies' Hermitage Association. The president was en route to Washington from a hunting trip in Mississippi when, on October 22, 1907, he spent a few hours in Nashville.

Roosevelt gave the Hermitage ladies his backing for a federal appropriation for their project to restore the Jackson mansion. The ladies gave him a cup of coffee, and a marketing legend was born. The hostess

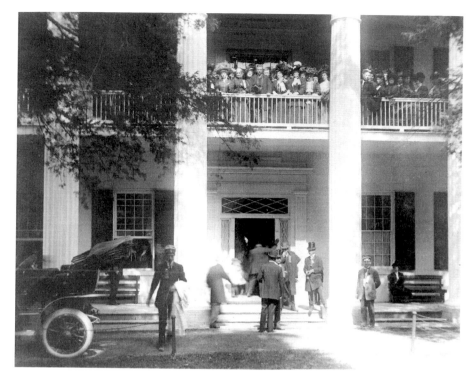

In 1907, President Theodore Roosevelt stands on an upper veranda at the Hermitage, surrounded by members of the Ladies' Hermitage Association. *The Tennessean file.*

asked him if he would have another cup of Maxwell House Coffee. "Will I have another? Delighted! It's good to the last drop!"

Writer Bill Carey, a former *Tennessean* reporter, questions in his book on Nashville business history whether the coffee Roosevelt was served was, in fact, Maxwell House, let alone whether the comment was real. Carey researched newspaper reports at the time and could find no hard evidence of either.

However, longtime Nashvillian Geneva Bryan, who once had Cheek as a dinner guest, at age ninety shared Cheek's version of the story. He told her that he had been seated next to Roosevelt at the time and that the comment was genuine, but it came in response to Cheek's request for the president's opinion.

True or not, the story has long outlived those with firsthand knowledge of it and has helped build Maxwell House into one of the world's best-known brands.

Cheek, the coffee's originator, was a former horseback salesman of wholesale groceries who had a remarkable gift for marketing research. He knew that America was ripe for a mild and uniform coffee flavor produced by blending several types. Coffee from pre-roasted beans was even better in an age when homemakers had to cope with preparing the beverage

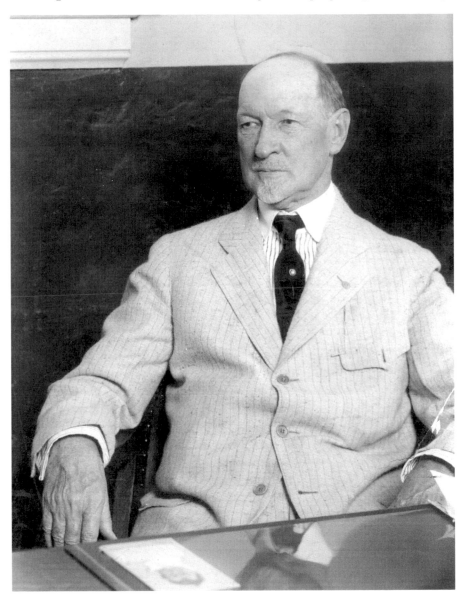

Joel O. Cheek, founder of Maxwell House Coffee. *The Tennessean file.*

from beans still as green as when they were shipped from the plantations of South America.

The right blend and savvy promotion made Cheek a pre-Depression multimillionaire when, in 1928, he sold his company to Postum Co., later to become General Foods. The price was a reported $21 million in cash and another $21 million in stock. By that time, Cheek-Neal Coffee Co. had moved to Cummins Station from its earlier location on Second Avenue, then called Market Street.

Three years earlier, Cheek had suffered a stroke, causing partial paralysis. Six of his eight sons were helping in his coffee empire at that time and were beneficiaries of his foresight. Another son, John Cheek, who died in 1975 at age eighty-five, opened in Nashville one of the nation's first dealerships for Dodge cars.

A MUSIC ROW MANSION'S STRANGE CURSE

In the mid-1960s, while we were living on Sixteenth Avenue South, there was a large two-story house on the corner of Sixteenth and Edgehill that had once been quite impressive. But it was showing its age and lack of care. Two sisters lived there, but no one saw much of them except as they might pass by an upstairs window. The story was that their father, who for some reason was not in the "social register," gave an elaborate ball for them one year and no one attended. After that time, the sisters rarely left the house and had no contact with anyone other than their parents. The parents had died before the 1960s sometime. The sisters still lived in the house, virtually forgotten by everyone. Can you find their story?

—LaVelle Boyd, Nashville, Tennessee

The grand stone house with its two-story portico at 1111 Sixteenth Avenue South no longer stands, but few Nashvillians who saw it or heard the facts surrounding it can forget it completely.

Aspirations, cruelty, revenge, loneliness, determination—even questions about the afterlife—all of these are woven into its unique tale, pieced together here largely from newspaper accounts from 1974, '77 and '85.

Jacob Schnell, an industrious German immigrant, was part of Nashville's growing Germantown suburb just north of downtown. He

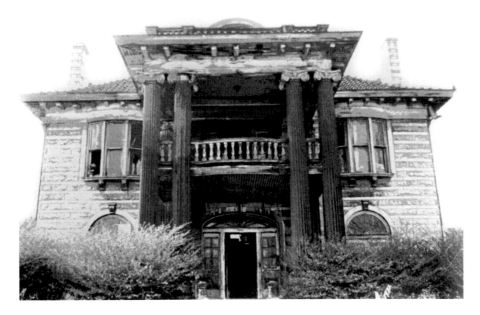

The Schnell mansion at 1111 Sixteenth Avenue South was showing intentional neglect long before this 1970s photo prior to its 1977 demolition. *The Tennessean* file.

established himself as a grain merchant. On September 30, 1873, he was married to Jennie Powell.

The happy couple produced four attractive offspring, a son and three daughters. They lived, as was the custom in those days, above their feed store on Jefferson Street.

Jacob's hard work resulted in great financial reward. Wanting the best for his family, he bought property in a fashionable early 1900s development southwest of downtown, where he built a spacious home. (The street is now known as Music Row, but that is another story.)

As his daughters neared the age when beaus should be coming to call, Jacob decided to play host in the new mansion to an appropriate party, marking what he saw as their debut into Nashville society. An orchestra was employed, food was ordered and all details were tended to.

Unfortunately, the time was not a good one for people—however industrious—of German descent. A war had given Nashvillians, even those of inherent good intentions, a suspicion of people from that part of Europe.

Hardly anyone, and certainly no one of note in Nashville society, attended Jacob's ball in his third-floor ballroom. He was furious that his daughters should be snubbed in such an uncaring way.

Jacob decreed that his new and expensive mansion in its fashionable location from that day forward should be allowed to fall into a state of disrepair. It would become a constant reminder to anyone who passed by of the injustice his daughters and family had suffered at the whim of Nashville society.

Jacob moved back to Jefferson Street above his business, leaving his wife and children in the grand home. His son, later a city councilman, eventually moved away. One daughter later married and left. The two others, Lena and Bertha Schnell, stayed put and carried out their father's directive, even long after his death.

Paint was not applied. Pipes that burst in the winter cold were not fixed. Buckets caught roof leaks. Pigeons took up residence. Draperies were allowed to rot and fall.

Lena died. Bertha—described as well educated and genteel by the few who came to know her—kept largely to herself. In the winter, she closeted herself and her dog, Andy, in a single room with functioning heat. She often wore rags. Water was hauled in. Many neighbors, even into the 1970s, remained horrified at the state of the house.

Bertha's death at age eighty-four on June 30, 1974, brought an end to her father's curse on Nashville—or did it?

Rat-infested furnishings, including fine mahogany furniture, were sold at auction late in 1974. Any salvageable features of the house were also removed and sold before its demolition in the spring of 1977.

A large office building was erected on the site, becoming the Nashville home of Capitol Records. The newly occupied building soon began to raise concerns among its tenants.

Certain second-floor rooms would remain icy cold, even when controlled by a common heating system. Computers and printers would misbehave in bizarre ways. Unexplained minor fires and pipe breaks occurred. Some employees became spooked.

A psychic who claimed to have knowledge of ghostly things was brought in to exorcise any ill will remaining. Spirits were supposedly detected and coaxed into leaving. Remaining Capitol tenants reported few problems.

DEMONBREUN'S RIVER-VIEW CAVE

As a child in the 1950s, I remember riding with my family in our boat on the
Cumberland River. Once I saw along the river cliffs a cave-type structure that was
enclosed by metal bars. My father thought the cave had something to do with one of
the first Nashvillians, Timothy Demonbreun. Can you tell me anything about the
image of this cave I have remembered for so many years? Please tell me if it is still
in existence and where it is located.

—Phyllis Terry, Nashville, Tennessee

Few Nashvillians have seen it and no architect was involved in its
construction, but this is probably the city's earliest remaining home. It also
may be Nashville's only property listed on the National Register of Historic
Places that requires a boat trip on the Cumberland River for easiest and
best viewing.

How did Timothy Demonbreun even get his family inside this secluded
niche high on a river cliff face? It appears that a boat and a rope ladder were
both necessary.

Once inside, with the ladder withdrawn, his family had a low-cost
version of the area's first safe room—hidden away from Native Americans
protective of their hunting grounds and from the "wild beasts" that
inhabited the region.

The little cave has become known in legend as the birthplace and nursery
of Nashville's first child of European descent, Demonbreun's son William.
(William later moved to Williamson County but is not the source of that
county's name. It was named for Dr. Hugh Williamson, surgeon general of
the North Carolina militia.)

The settler, whose full name was Jacques-Timothe Boucher Sieur de
Montbrun (1747–1826), was a fur trader born into a noted Quebec family.
He has been described as "Nashville's most picturesque pioneer." He came
here about 1769, after periods in Quebec; Vincennes, Indiana; and the
Illinois territory, where for a while he served as lieutenant governor.

Rowing up the Cumberland to the bluff where Nashville later developed,
he discovered the salt deposits that attracted bison, moose, deer and elk for
easy hunting. The spot became known as "French Lick," near the present
Jefferson Street. The area south of it was given the name Sulfur Dell because
of the smelly sulfur water noted by Demonbreun.

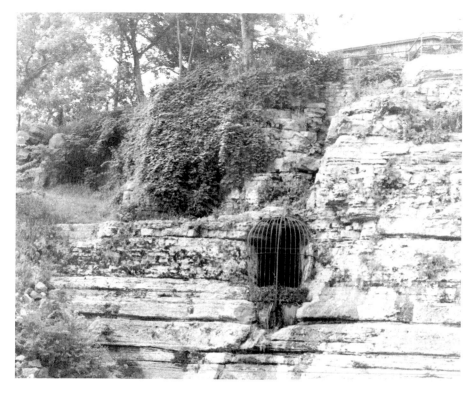

This small, barricaded cave in a rock bluff along the Cumberland River is one of Nashville's earliest refuges, home of pioneer Timothy Demonbreun. *The Tennessean.*

In earlier travels on the river highways of the day, he had discovered the mouth of the Cumberland River, so it was appropriate that the cave where Demonbreun later spent several winters overlooked it.

His subsequent homes in the downtown area were more conventional, culminating in one located at the present northwest corner of Broadway and Third Avenue, where he lived the longest and resided at the time of his death.

His last rites were Catholic, the faith he and his family introduced to Nashville by helping organize an 1820 church.

The cave that nurtured Nashville is officially located at 1700 Omohundro Drive, although it is not visible from there. It lies a bit east of Brown's Creek and west of Mill Creek, on the opposite bank of the Cumberland from Vinny Links Golf Course and Shelby Park.

MYSTICISM, ECCENTRICITY AND A FUNERAL HOME

How did a funeral home become located on a corner of the Centennial Park tract?
—Ron Sanders, Nashville, Tennessee

The landmark that is Marshall-Donnelly-Combs at the busy intersection of Elliston Place and Twenty-fifth Avenue North, just feet off West End, wasn't always a funeral home. Its twisted history involves spirits and séances, but not on that site, and a midnight funeral, but not there and far from a satanic one. It also includes a widow—wealthy, outgoing, older than her eccentric husband and eager to leave his downtown mansion, which Nashvillians of the day were sure was haunted.

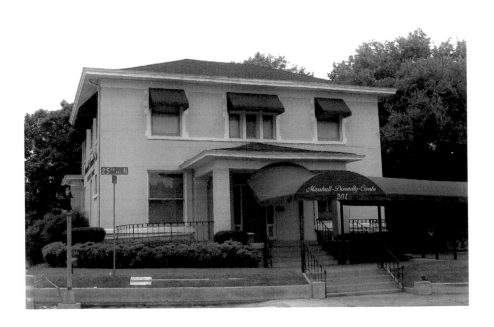

The Marshall-Donnelly-Combs Funeral Home on Twenty-fifth Avenue North was built as the house of a widow who earlier participated with her husband in séances. *George Zepp.*

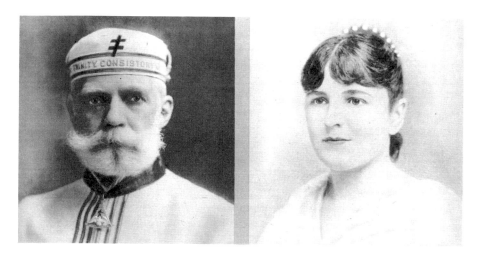

Ben Allen, in Masonic garb, and Sue Allen. *The Tennessean file.*

When the Centennial Park site was developed in the years leading up to the 1897 Centennial Exposition marking Tennessee's 1796 statehood, the corner next to its main entrance narrowly escaped being included. Several areas near the centennial grounds were described as heavily wooded and considered almost rural.

On the larger original funeral home tract—some of which is now parkland—were four frame buildings, two of them stables or sheds. These show up in an 1889 atlas of the city that lists its owner only as "Jones."

In the 1880s, what is now parkland was the site of the state fairgrounds and West Side Park, a horse-racing track. A streetcar line linked it to downtown. The street now called Twenty-fifth was then Fair Grounds Avenue.

Percy Warner and the Nashville Railway and Light Co. bought the initial seventy-two acres of Centennial Park for $125,000 and gave it to the city's Park Board in 1902. Warner had earlier planned to subdivide it and sell it piecemeal.

Prosperous widow Sue Allen purchased the property where the funeral home sits soon after her husband's death in 1910 and built the house it now uses. She moved there from her old home downtown on Eighth Avenue in 1912 and lived in the fashionable residence next to the park until 1923. That year, she sold the property to longtime Nashville undertakers M.S. Combs & Co.—whose business began in Nashville in 1872—and moved to her family's home, Edmiston Place, on Franklin Road near Brentwood.

Allen and her husband had been colorful characters in downtown Nashville. Benjamin Bentley Allen, for whom the current Ben Allen Road in Inglewood is named, was described as "a well-bred, artistic gentleman of leisure" by writer Margaret L. Warden in her 1951 profile of him in the *Nashville Tennessean Magazine*. Son of a wealthy banker, he had developed a reputation as a jewelry-making hobbyist, a Freemason, a hypnotist, a palmist and a supernaturalist.

Ben Allen hosted séances about twice weekly at his brick residence at 125 Eighth Avenue South. The spirit conjured up—"The Thing"—would rub against legs like a cat, unbutton shoes, remove stockings and rattle silver and china. Allen also gave his wife—the "medium" for the séances and eight years his senior—elaborate birthday parties there. His prized treasure was a gilded Buddha figurine, given to him by a traveling Persian mystic and magician while on a visit to Nashville.

Allen, born July 5, 1855, died at age fifty-five on July 13, 1910, of what was called at the time "brain fever."

"Some thought he brought it on by trying to fathom too many deep mysteries," Warden observed.

She described Allen's funeral as the first "Kadosh," or midnight Masonic service, held in this part of the South. The service was at McKendree Methodist Church on Church Street, its sanctuary lighted by only nine candles on the altar. About one hundred Masonic knights in black robes followed the body.

Sue Allen's house at 201 Twenty-fifth Avenue North, now the funeral home, still has many of its original features, including elaborate marble parlor mantels. The outside looks remarkably the same, down to a stained-glass window on the West End side. An attic dormer in the front is gone, but the stable building with its wooden doors remains in the rear.

Marshall-Donnelly-Combs is a Nashville success story in itself. It remained locally owned from 1872 until 1997, when it was bought by the Florida-based funeral home chain Keystone Group Holdings Inc.

STREET BLUES NETS DIMES AND A GRAMMY AWARD

As a child I remember going to downtown Nashville with my grandmother on Saturdays. There was a black bluesman who was blind playing his guitar for coins just across Fifth Avenue from the Arcade. I loved to listen to him play, but my grandmother didn't want

me to hear "the devil's music," as she called it. His name was Cortelia Clark...I'm pretty sure he recorded at least one album before his death in a house fire at his home. Can you tell me more about Mr. Clark?

—*Dale Spicer, Dickson County, Tennessee*

Blind since age twenty-five, this street musician became something of a legend in Nashville music circles. What other recording artist relied on coins dropped in his tin cup from sidewalk sales of both songs and ten-cent shopping bags? Who else could boast a Grammy award for his first and only album, even though it initially sold fewer than one thousand copies?

Chicago-born Cortelia Clark moved to Nashville in his teens to work in a broom factory. Another blind man had taught him to play the guitar.

As Clark told it in an interview included on his 1966 album, *Blues in the Street*, he started singing at night for World War II–era crowds lined up outside two of Nashville's downtown movie theatres, the Paramount and the Loews. Eventually, he worked his way to a regular spot in front of Woolworth's on Fifth Avenue North. There he belted out blues-folk tunes for donations while marketing his bags—ten or twenty a day, more on Saturdays—from a folding chair. Receipts in a good week ranged up to thirty dollars.

"I don't much like to come to town when it's raining. And I don't like the cold. That winter bites!" he told *Tennessean* reporter Kathy Sawyer in May 1967. He was back on the street again two months after his Grammy honor, drawing welfare despite his nationally publicized fame and the three-quarters of a cent he was getting for each record sold.

Clark's work—he authored eight of the eleven songs on the album—won in the folk category that year over such greats as Pete Seeger, Joan Baez, Lead Belly and Peter, Paul and Mary.

How the album came to be was a miracle in itself. Mike Weesner was age seven or eight when his mother brought him downtown and he began to hear Clark. By age twenty-five, Weesner owned his own music publishing firm. He made a sample recording of Clark and took it to RCA, where Felton Jarvis—Elvis Presley's producer—agreed to record the street musician.

Despite the Grammy, RCA dropped Clark from the label. Weesner remained upbeat.

"The Grammy isn't presented to the one with the most sales...It is presented, simply, to the best," he told *Tennessean* reporter Frank Ritter.

Two years later came the November fire at Clark's 934 Jefferson Street home. He was filling a kerosene heater when it exploded, engulfing the small

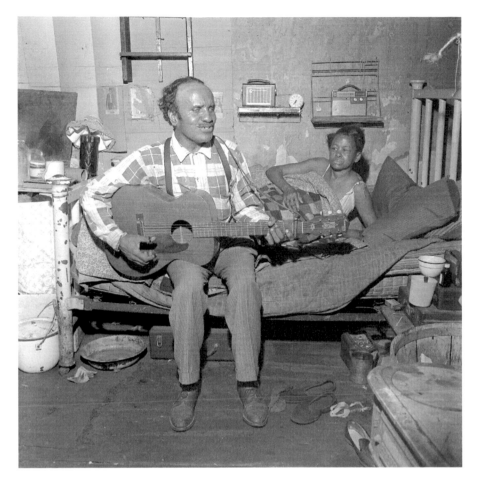

In May 1967, the year of his Grammy, street bluesman Cortelia Clark strums a tune for his wife, who is in bed suffering from a foot corn. *Dale Ernsberger,* The Tennessean.

wood-frame house. He lingered with burns in the charity ward of Hubbard Hospital but died on Christmas Eve 1969. A friend said he had stopped eating the hospital food because it wasn't as good as his wife's. His age was described as between sixty-two and sixty-seven.

Twenty people, including the minister and a TV cameraman, attended his funeral. Songwriter Mickey Newbury (1940–2002) later penned a tribute song called simply "Cortelia Clark." The tune recounts Clark's life and sad end and then asks: "Can you save a street in glory for Cortelia Clark?"

SHRUNKEN HEADS,
BIG MUSEUM MYSTERIES

What happened to the shrunken head that was on display at the Children's Museum in Nashville back in the late 1960s? I vividly remember the head being small and black. My father and grandfather were very well-known taxidermists at that time, and my father restored the shrunken head at one time.

—*Carol Hillman, Grapevine, Texas*

Some Nashvillians may recall that there were once two shrunken heads at the little museum, now transformed at a different location into the larger Adventure Science Center. In fact, one of the South American heads went "missing" and caused a bit of a stir. One Sunday in June 1960, someone snatched the tiny curiosity—the male one—from its display case.

Police were notified. A photo "head shot" was supplied.

Not many weeks passed before it resurfaced in an unlikely spot. Libby Battle went to her mailbox in the Oak Hill neighborhood and found something strange inside.

"At first I thought it was a bird nest. Then I looked again and saw it wasn't. I saw its ear and eye. It wasn't a nice feeling," she told a reporter at the time.

Battle, whose husband, Bob Battle, was city editor of the *Nashville Banner* newspaper, turned it over to museum director Philbrick M. Crouch.

"Shrunken heads have been hard to get for years," Crouch said, adding that South American governments had banned their sale.

A museum display label for the heads attributed them to the Jivaro Indians of the Amazon River basin. It said that the Jivaros behead their enemies and then shrink the heads.

The little heads were reportedly a gift to the museum from notable Nashville businessman and science buff Arthur J. Dyer, who died at age eighty-nine in 1957. The Nashville Bridge Co. founder and Vanderbilt University supporter was honored when the university's astronomy observatory was named for him in 1952.

A yellowed clipping in newspaper files tells of Dyer's trip with his wife to Chile in 1951. It doesn't mention the heads but said it was the couple's second trip to South America.

Dyer, in his role as chairman of the Nashville Planning and Zoning Commission, had brought about several post–World War II innovations for the city. Parking meters, a sewage treatment system, looped streets around

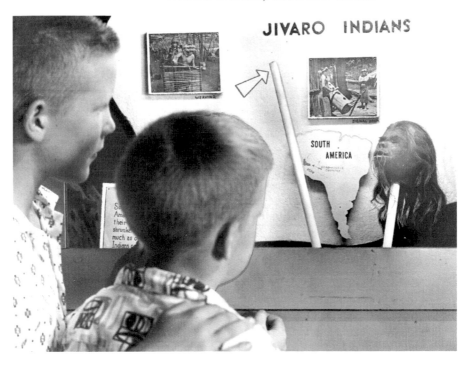

In June 1960, boys visiting the old Nashville Children's Museum stare at one of two South American shrunken human heads displayed there. *Joe Rudis,* The Tennessean.

downtown and even the Municipal Auditorium all grew from ideas he outlined in 1944.

Dyer's little heads have been moving around again in more recent times, but not to Nashville mailboxes.

The Children's Museum sold much of its old collection years ago when its mission changed course, said Virginia Crowe, marketing director for the Adventure Science Center.

The Scarritt-Bennett Center's cultural museum received the shrunken heads in 2000 but later determined that they didn't fit with its collection, said Adriana Larios, the center's curator. In 2006, the heads were entrusted to Vanderbilt University's Anthropology Department.

Nashville at Play

Swimming, Skating and Movies

Cascade Plunge's Fifty-two-Year Splash

At the fairgrounds there was a huge slide at the swimming pool. I heard that someone regularly put razor blades on it and many a poor soul slid down it and was cut badly by them. I never went down that slide again. I wonder, was it true?
—Pat "Judy" Gatley, Centerville, Tennessee

The tale of razor blades on the tall Cascade Plunge slides has been cited as one of Nashville's top "urban legends." It's a great story, but not true. Scary but true, however, was a near drowning in the popular pool at the state fairgrounds in 1972, two summers before Cascade Plunge closed.

It was late in the afternoon on a Saturday in June. Marvin Avery, then of 1223 Fifth Avenue North in the Germantown neighborhood, and a friend decided to head to south Nashville for a swim. Somehow, Avery's arms and legs failed him, and he ended up on the bottom of the pool, losing consciousness.

The eyes of the fifteen-year-old were wide open underwater, perhaps reflecting the horror of his situation, when two seventeen-year-old lifeguards pulled him out and revived him.

"I looked down from up in the level of the phone poles and saw myself being resuscitated," Avery recalled thirty-one years later from his east Nashville home, describing what he said was an "out-of-body experience."

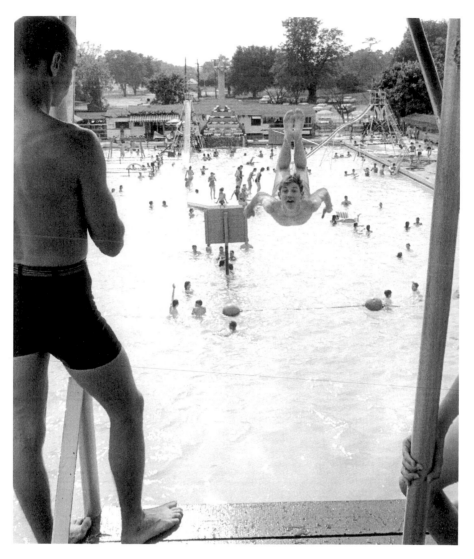

Cascade Plunge was a busy spot in June 1963, when Eddie Kendrick tried a one-point platform dive. The popular pool remained open for fifty-two years. *Gerald Holly, The Tennessean.*

Lifeguard Allen Herald, a McGavock High School student, administered mouth-to-mouth resuscitation. "He would breathe some, and then stop," Herald told a reporter that day.

"I guess you know I don't swim any more…but I still fish," said the adult Avery, who went on to pursue a career as a nurse technician.

Cascade Plunge was known to many Nashvillians for carefree fun rather than terror. Its longtime operators, Wilma and Edwin H. Jones, had a flair for water entertainment, which engaged the imaginations of thousands over the years.

Synchronized swimming, a fire-diving water clown (soaked in kerosene and lit), local music "combos" and even a ten-ton ice pyramid with a "Miss Iceberg" contest attracted spectators well beyond the hundreds who flocked to the pool daily for swimming, sunning and socializing.

Normal admission was once just seventy-five cents to one dollar for a whole day of outdoor amusement, from 10:00 a.m. to 10:00 p.m. When air conditioning was expensive or nonexistent for many, pools were cool bargains.

"A lot of romances and marriages came out of there," the late Les Jameson said in a 1984 interview. Jameson (1930–1996), a Nashville radio personality, had been a Cascade Plunge lifeguard beginning about 1955 and first came here as one of a trio of young Englishmen with a comedy diving act.

"The parking lot would be full of convertibles and ladies in their swimsuits. It was a very social scene. Everybody was there," he recalled.

The privately operated pool on Davidson County land became so popular that local politicians sought more control of it. In November 1941, it was transferred to the State Fair Board, but Jones—the pool's previous manager—got an operating lease the next spring. Metro Parks ran it later.

The pool was a segregated facility where African Americans were not allowed until 1968. Desegregation in the 1960s and racial attitudes at the time were among the reasons for eventual closings of several public pools in the area. This one and others also ultimately needed expensive renovations.

At two hundred by eighty feet, Cascade Plunge was once one of Nashville's five largest pools. It boasted two water slides, a sixty-foot-tall diving platform, two one-ton Spanish anchors and fountains, and it once had a restaurant.

Burke Wrecking Co.—its slogan "Burke Wrecks Another"—was paid $8,399 to fill the pool and level its structures in the spring of 1975.

LANDLOCKED SHIP IN CENTENNIAL PARK

In Centennial Park, there is a cement storage building that resembles a Spanish American War–era battleship bow. What is this?
—Robert N. Anderson, Nashville, Tennessee

Growing up in Nashville, we always liked going to Centennial Park and the Japanese Gardens—walking over the stone bridge, the water and goldfish, the flowers and the big Buddha…Could you tell me…why they took away all the water, fish and Buddha?
— *Doris Justice Zirbel, De Pere, Wisconsin*

Thousands of Davidson County residents and visitors flock to the old favorite Centennial Park each year, some of them asking the same questions. There have been others as well. Jay Harris of Franklin has long wondered about the mystery bell hanging on a tall tripod west of the Parthenon. Billy J. Slate of Hermitage recalled the Buddha and speculated that it could have been "melted down for metal" to use in World War II. Some of the park's riddles are easier to solve than others.

Leland R. Johnson touched on a few of them in his 1986 book, *The Parks of Nashville*. Others were topics for the late writers Hugh Walker and Louise Davis, who chronicled Nashville's past for *The Tennessean* newspaper.

For instance, there's the concrete ship's prow. It's still there near Twenty-fifth Avenue North but shows signs of weathering from its one hundred years.

The ship and several other decorative items in the park owe their existence to Major E.C. Lewis and his interest in reinforced concrete. Among these items was the concrete shell that once marked a spring, an arch bridge in Lake Watauga and a mushroom-shaped bandstand. All of them dated to the 1906–10 period.

"The use of reinforced concrete for construction then was novel, and the structures built in the park attracted nationwide attention among engineers," Johnson wrote.

Lewis was board chairman of the Nashville, Chattanooga & St. Louis Railroad and had been director general of the 1897 exposition at the park site to honor Tennessee's 1896 statehood centennial. When the exposition grounds were converted into a city park in the earliest years of the twentieth century, Lewis also played a major role.

The ship once greeted everyone arriving through the park's main entrance when it was located off Elliston Place.

The ornate metal figurehead was the original cast used to make the one on the United States cruiser *Tennessee* in the era of the 1898 Spanish-American War. The cast was exhibited at the Seattle Exposition in 1909, "where viewers called it one of the most beautiful ever made for an American warship," Walker wrote.

Navy admiral Albert Gleaves, then a captain, suggested that it be sent to Nashville. Lewis oversaw preparation of the concrete prow on which to

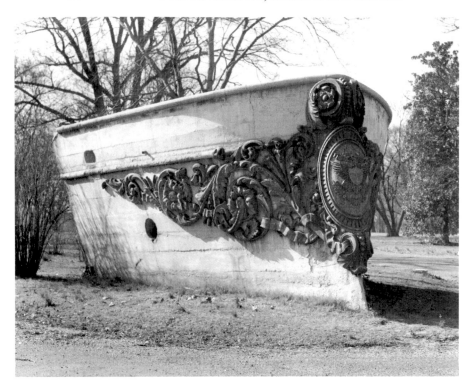

This landlocked partial ship in Centennial Park has been a Nashville feature for a century. This 1948 photo shows metalwork exhibited at a 1909 Seattle fair. *Ralph G. Morrissey*, The Tennessean.

mount it. The result left it "looking like a ship that had been driven ashore in the shrubbery," Walker noted.

Gleaves (1858–1937) was born in Nashville. His forty-five-year navy career included command of the cruiser and transport force that convoyed American troops to Europe for World War I. In the Spanish-American War, he had commanded the torpedo boat *Cushing*.

The Japanese Garden and the seated Buddha were once in a sunken flower bed area now popular for tulip viewing and outdoor weddings. The garden originated in 1922. "The statue was modeled by Jack Schwab, a Nashville sculptor, and was cast in concrete by G. Mattei," *Tennessean* writer John Lipscomb reported.

Mounted on a three-foot stone pedestal, the statue, with its upturned palms, began to attract donations of small change. Its nose had been missing since 1935. One theory held that it was damaged in a rock fight between small boys arriving to claim the coins.

Lipscomb's 1947 article for the newspaper's magazine section was headlined "Drowning Buddha." It seems that one night that year some "hellions" had pried up the contemplative fellow and toppled him headfirst into the lily pond.

Davis wrote two years later that the Buddha's neck—she said it was iron—had been broken in the fall. Both it and the garden, with its beautiful water lilies, were by then "war casualties," she said. "Not because the garden happened to represent an enemy…but because the labor shortage made it impossible to give the lily bulbs all the attention they demand in storage."

J. Percy Priest Dam and the Plot to Explode It

Do you know any of the history of Percy Priest Lake? For instance, how many people had to give up their land? How long did they have to move? How long did it take the Stones River to fill up the land that is now a lake? Were there any cemeteries covered by the water? I've never seen any of this in the usual info about the lake.

—Vivian Kannon, Antioch, Tennessee

On any given day, thousands of motorists traveling Interstate 40 just east of the city glance at the impressively close J. Percy Priest Dam. Others, as passengers taking off from or landing at nearby Nashville International, also get an aerial glimpse of the dam. At least a few of them must wonder from time to time how it came to be there.

When the dam was completed in 1968, President Lyndon B. Johnson came to Nashville to attend the official dedication. Criminals once plotted to blow it up, actually setting off a case and a half of dynamite inside a tunnel running through it. Boaters and swimmers by the thousands have enjoyed more than forty years of water pleasure from the recreational pool it created.

But backing up to the project's 1963 beginning, the dam didn't come easily. Workers' strikes and bad weather were among the many hindrances to the $50 million project. About twenty-eight miles of roads had to be rerouted. While 14,200 acres were to be flooded, 20,000 were being acquired. Government planners tried to prevent the intrusion of private development and access that had mushroomed on the shores of the earlier Old Hickory Lake.

Included at Percy Priest were nearly thirty-two hundred acres seized through condemnation proceedings when owners fought the federal offers.

More than 1,110 families in Davidson, Wilson and Rutherford Counties were gradually relocated as their properties were acquired. Dwellings and barns were sold by the state to buyers for removal.

In the end, about ninety-five cemeteries were moved. Many were little family graveyards, a few dating back as far as the 1790s. Hundreds of the estimated sixteen hundred graves and about seventeen of the cemeteries carried no names. "Here Lies a Democrat," said one epitaph, and nothing else. Most of the dead were relocated to Mount Juliet Memorial Gardens after being put in new pine or poplar boxes.

About 475 markers and some nearby ornamental shrubbery were moved with the remains as part of a $114,000 federal grave removal contract. If no markers existed, the government provided cement ones with metal plaques. In rare cases, bodies not moved lie to this day deep beneath the lake's 130 billion gallons of water.

"We have to get all the next of kin to make such a request," Clifton P. Carter, chief in 1965 of Nashville's U.S. Army Corps of Engineers, said at the time. "If the family insists, we leave the body where it is."

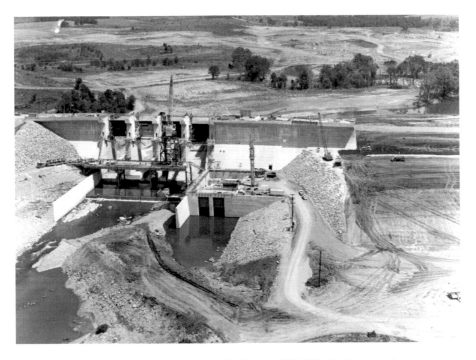

J. Percy Priest Dam was under construction in August 1967. The land seen at the top was submerged when the gates closed later that year. *Bill Preston,* The Tennessean.

Carter told a reporter that year that the graves project was so detailed that "100 years from now, researchers will be able to tell exactly where they came from and where they went."

Goals of the federal dam project were to provide electricity (the power plant went online in 1970), flood control and recreation. The reservoir began filling in September 1967, growing about six inches daily and reaching the desired level of 480 feet above sea level by May 1968.

Presiding at the dedication on June 29 that year, President Johnson said that the project would protect homes from floods and give Nashville electricity to "grow and prosper." Most important, "to me at least," he said, "it will create a beautiful new recreation area within 10 miles of the very center of Nashville."

One of the project's legacies is Long Hunter State Park, made possible through a 1972 federal lease to the state. It includes a 110-acre lake created when Percy Priest water backed up through a cave system into sinkholes.

The dam, originally to be named after Stewart's Ferry, ultimately carried the name of U.S. Representative James Percy Priest (1900–1956) of Davidson County, a former *Tennessean* newspaper reporter and editor.

As for those dam bombers, their plan didn't quite work. The November 1978 incident still won a place in local lore as one of the craziest criminal schemes ever attempted here. The ill-conceived scenario was to flood downstream Nashville stores, which could then be looted using scuba gear.

The bombers' relatively small amount of dynamite and ineffective placement of it caused only about $10,000 worth of minor damage to the 130-foot-high dam structure. No water was lost. Even if the dam had been breached, experts said that flooding would not have reached the areas the thieves had hoped.

The Nashville/Goodlettsville/Mount Juliet trio—all in their twenties—who planned the grand heist received federal prison sentences as their only rewards.

HIPPODROME'S SMOOTH SKATING AND ROUGH WRESTLING

After my discharge from the Army in 1946, my wife and I lived in an apartment on Murphy Avenue close to Elliston Place…A friend and I went to the wrestling matches at the Hippodrome on West End. I believe the promoter was Nick Gulas and

two of the wrestlers I remember were Tex Riley (the good guy) and Tojo Yamamoto (the bad guy). Do you have any photos or information about the Hippodrome and the wrestlers?

—*Ray Houle, Madison, Tennessee*

Wrestling was just one of the many clever uses for this forty-thousand-square-foot roller rink that served Nashville as the city arena of its day. Big band performances, dances, kids' skating parties, shows by black musical legends and even YMCA league baseball games on skates were some of the others.

Walking marathons were a hit of the 1930s, with couples holding each other to fight off sleep and win cash prizes. Vanderbilt University's basketball team played under the skate floor streamers in 1937–41.

Trade shows there included the state's funeral directors, exhibiting everything from ambulances and caskets to stylish burial clothes. The *Nashville Tennessean* sponsored Golden Gloves boxing, while the *Nashville Banner* sponsored a radio show.

"There were all kinds of acts, even some with horses," Mary Jo Bargatze recalled in 1968, the year the Hippodrome closed.

Bargatze remembered the first building, a wooden one from 1906 with heat stoves in its four corners. She skated there starting in 1908. A brick replacement followed by 1914, when it was part of Nashville entertainment entrepreneur Tony Sudekum's Crescent Amusement Co.

Nashvillians flocked to the Hippodrome across from Centennial Park. In the early days, they arrived by streetcar to skate all evening for a quarter or less. Crowds ranged up to the three thousand skating capacity as the house organ set the pace. Bargatze's daughter, Evelyn Vaughan, once sat at the keyboard.

Former Fort Campbell soldier Clarence Bowles, sixty-six, of Erlanger, Kentucky, marveled at the smooth, ebony floor he glided across in the 1960s any time he could get leave from the army post near Clarksville.

"It was the best rink I've ever skated on at that time and since," Bowles wrote. "It was so black to gaze down at it while skating was like looking into a beautiful young lady's dark eyes. It had this bottomless sensation."

"There was a lot of laughter, a lot of fun in this place," said Gertrude Gregory, the last manager of the facility, who started on its staff in 1942.

"I don't believe there's a place left around here that meant so much to so many as the Hippodrome," wrestling promoter Nick Gulas told a reporter in 1984.

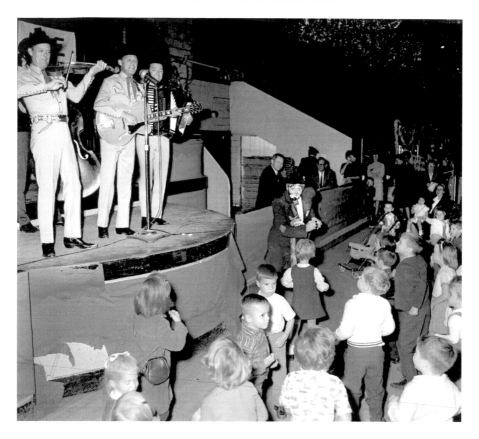

Kids dance to the Willis Brothers at the popular Hippodrome during the 1965 Christmas Village. The multipurpose skating rink building was removed in 1968. *Bill Preston*, The Tennessean.

Gulas discovered the Hippodrome about 1937, after coming to Nashville from Birmingham. The promoter went on to stage many Tuesday night wrestling matches there, as well as big band dances in the late 1940s.

Benny Goodman, Xavier Cugat, Harry James and Sonny Dunham were among the acts. In the 1960s, it was jazz, rock and R&B. James Brown, Lou Rawls, Sam Cooke and others all played the Hippodrome.

Tojo Yamamoto (Harry Watana), who died in Hermitage, Tennessee, in 1992, and Tex Riley, who died shortly after a wrestling match in Savannah, Georgia, in 1964, were both familiar names on the Nashville professional wrestling scene.

Riley was a longtime partner of Leon Rossi. Together they once held a World Tag Team title.

The Hippodrome's size was both its early blessing and later curse. Since it required about fifteen employees to operate, staying in business became less economical.

The 1964 *Tennessean* newspaper headline "Hippodrome Triangle Sold" announced the beginning of the end for that use on its part of the four and a half acres between West End Avenue, Natchez Trace and Twenty-eighth Avenue South. The plan was to construct a thirteen-story hotel, the largest Holiday Inn of its time in the South. The Holiday Inn Select Vanderbilt remains in business today at 2613 West End Avenue.

Old-timers staged a "last lap" skating party on March 26, 1968, before demolition began. A June 13 fire sparked by workers cutting its steel beams hastened the Hippodrome's demise.

HILLSBORO VILLAGE THEATRES, BELMONT AND BELCOURT

On Aug. 30, 1925 there was an advertisement in the Nashville Tennessean *about the grand opening of "the new Belmont," said to be "Nashville's finest and most up-to-date theatre." It was brought to us by Tony Sudekum, whose picture also was in the paper. I have asked several senior citizens if they remember it and they said no.*

It was very large and sat at Twenty-first Avenue and Blakemore. It was to have theater, music, plays and would feature the Belmont Concert Orchestra under direction of F. Arthur Henkel, Nashville's director of the Nashville Symphony Orchestra… Can you find out anything about it?

—Frank Feinstein, Nashville, Tennessee

Many Nashvillians are familiar with the Belcourt Theatre in Hillsboro Village, but fewer recall the Belmont on the corner of what is now Twenty-first Avenue South at Blakemore/Wedgewood. The two movie houses shared opposite sides of the same block in the mid-1920s.

The larger Belmont made the smaller Belcourt (then called the Hillsboro) less popular and brought about its closing as a movie house within a year or two, even as the Belmont prospered. But the Belcourt, with its new name in a later-expanded building, was the one left surviving into the twenty-first century.

Both theatres were connected with early motion picture chains emerging in the years before and after World War I.

Nashville entertainment entrepreneur Tony Sudekum's empire was the Crescent Amusement Co. It grew to at least ninety movie houses across three states in the ten years after its start in 1907, with eventual partnerships adding many more.

Sudekum opened the lavish 1,350-seat Belmont in 1925 and placed a large newspaper ad proclaiming it to be "truly an institution to be proud of" with its "silent drama." This meant no sound beyond an "organ overture" and the accompaniment of F. Arthur Henkel and his fifteen-piece orchestra.

The popular story was that architects Marr & Holman, who had crafted an elaborate Spanish style of exterior arches and tile roof elements, overlooked one important detail: a projection booth. The booth did protrude from an outer forty-foot wall, supported from beneath by beams. But that might have just been part of the style.

Sudekum himself had roughed out the design by tracing it in the sand while visiting a Florida beach.

The Spanish theme was initially carried inside as well. Ushers wore "Spanish costumes" for the premiere, a film called *I'll Show You the Town*. Reginald Denny played a college professor who tries to woo three women at the same time, with none of them the wiser.

Meanwhile, the smaller Hillsboro Theatre had opened just weeks earlier. It fronted with twenty-six feet on what is now called Belcourt Avenue but had an entrance at 1715 Twenty-first Avenue South, just south of the Belmont's address at 1701. A block of stores developed on Twenty-first by 1930 ultimately eliminated that passage.

Joseph Lightman and his son, Morris A. Lightman, were the Hillsboro's builders, according to the father's 1928 obituary. A Hungarian Jewish émigré, Joseph Lightman had been in Nashville since the 1880s as a fruit merchant and later a stone construction contractor.

After losing the local ticket sales competition to Sudekum, the younger Lightman didn't give up. He moved on to Arkansas to help develop what has now become the ongoing Memphis-based Malco Theatres.

The Belmont, which underwent a 1958 "art theatre" conversion, continued to attract movie fans. It closed in March 1961, two months before its demolition. The prominent Hillsboro Village office building that replaced it was long known for a credit union based there.

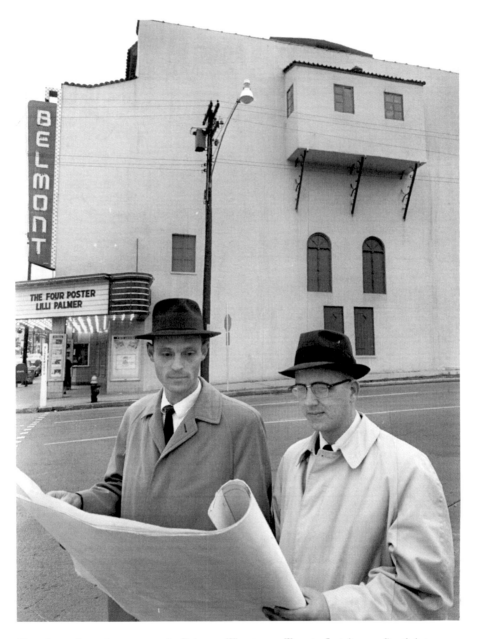

Plans later aborted to convert the Belmont Theatre on Twenty-first Avenue South into an office building are reviewed in 1961 by Wilbur F. Creighton III (right) and H.R. Slaymaker. *Jack Corn*, The Tennessean.

Meanwhile, the Hillsboro around the corner had been revived by about 1937 as home of the 1935-founded Nashville Community Playhouse. That live-drama organization evolved into Theatre Nashville.

In 1962, Fred H. Massey, owner of Massey Seating Co. and Nashville's Fair Park, leased the building and remodeled it to resume motion pictures. Occasional Theatre Nashville plays also remained in the newly named, 314-seat Belcourt Playhouse. The initial offering was a film called *Purple Noon*.

The Belcourt was expanded into a then novel two-screen theatre in 1968, just in time for the Nashville debut of the film *Elvira Madigan*. A new auditorium on the left was added with 439 seats, and the original was upgraded to 388. It remains largely in that form today under a nonprofit management structure.

Naughty Nashville

Drinking, Stripping and Cavorting

Heaven Lee, Star of Printers Alley

Whatever happened to the most famous stripper ever in Printers Alley, Heaven Lee?
She used to be the largest draw there for many years in the late 1960s and the '70s.
She became a local icon and was as popular as Tootsie's Orchid Lounge.
 —Michael Olcott, Santa Monica, California

She was perhaps the only stripper with a hit run of more than fifty-two consecutive weeks in Printers Alley, Nashville's answer to New Orleans–style entertainment, but Heaven Lee was full of contradictions.

A Cuba native and daughter of a wealthy plantation owner, she fled that country in 1962 for Spain, studied accounting but became bored by it and later adopted Nashville as her base. She was a public proponent of Christianity and prayer. She spoke to Nashville civic groups, once even leading a panel discussion on women's rights for a Vanderbilt University fraternity.

A night-on-the-town date with Heaven Lee was a featured item on Nashville's public TV fundraising auction in 1980.

During a 1979 gasoline shortage and price spike, Heaven Lee began to ride her bicycle to work in the Alley—in high heels—as a symbolic gesture. Her limousine followed on her maiden ride along Nolensville Road, even though it took more than twenty-five dollars to fill its tank.

"If we don't give the oil companies a chance to take our money, they can't continue to get such high profits," she said at the time.

Bob Rymer toasts Heaven Lee at the Brass Rail in Printers Alley. Rymer paid $175 in a 1980 benefit auction to spend an evening with the stripper. *J.T. Phillips*, The Tennessean.

Her first attention-grabbing public ride in Nashville was in 1970 on horseback down James Robertson Parkway to protest environmental pollution. Many thought she was nude. In fact, she told a *Tennessean* reporter later, she had worn a body stocking.

Her career here included an off-and-on ten-year run at the Black Poodle in Printers Alley. By 1980, she had reported earning $57,000 annually performing there.

As early as 1973, she had aspired to Las Vegas nightclub and movie stardom as a singer/dancer, but that was not to be. Nashville—"my adopted

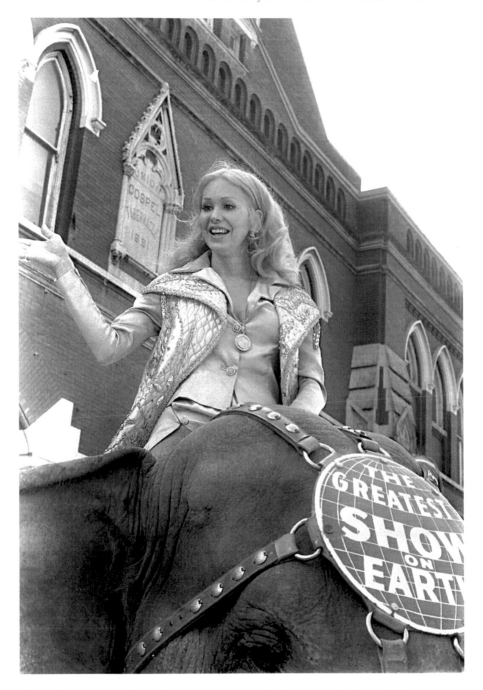

Exotic dancer Heaven Lee rides an elephant past the Ryman Auditorium in 1974 as the Ringling Bros. and Barnum & Bailey Circus heads for the Municipal Auditorium. *Billy Easley, The Tennessean.*

hometown"—was always the heart of her one-woman enterprise, even after a 1976–78 U.S. tour.

She overcame hardships: a nipple-covering metro pasties law in 1978 (hers were lace, in keeping with her view that "nudity is art"), at least two failed marriages and public rumors—angrily denied in a 1973 newspaper interview—that she was actually a transvestite.

Not unlike several Nashville music entertainers, she had a March 1980 drunk driving arrest (0.13 on a breath-alcohol test) and an October 1980 crash of her Cadillac limousine on Battery Lane that proved near fatal. No evidence pointed to alcohol in the crash, a newspaper report said at the time. Still, she spent more than a month in Vanderbilt Hospital with a fractured pelvis and couldn't resume work until December 15.

In 1981, she declared bankruptcy, citing debts of more than $100,000. Part of the financial problem was attributed to $22,000 in medical bills from recuperation following her wreck. Another factor was $55,000 in back taxes.

Heaven Lee appears to have severed ties with Nashville about 1990, as public records under her real name, Vianka de la Prida, indicate.

Michael Olcott, whose question is above, has been in contact with Prida over the years. He wrote that in 2005 she was living in Florida with her mother. Olcott said that Prida, now about age sixty-three, a self-described "survivor…through thick and thin," declined a newspaper interview about her past or more recent life.

SALOONS EVERYWHERE, EVEN THE OLD PUBLIC SQUARE

I have a brass token that was in a box of junk I bought in Memphis for 75 cents. On one side is "Good for 5 cents at bar" and on the other is "B.R. Demonbreun, 113 Pub. Sqr." Was B.R. Demonbreun maybe honored with a Nashville street named for him?
—John R. Setters, Whites Creek, Tennessee

Nashville saloonkeeper Bynum R. Demonbreun was actually a great-grandson of the early Nashville settler honored in the naming of Demonbreun Street. His ancestor, a Quebec fur trader whose real name was Jacques-Timothe Boucher Sieur de Montbrun (1747–1826), is remembered for having spent some of his earliest days after arriving here about 1769 in

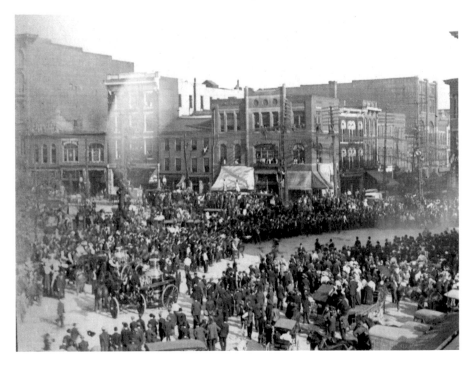

Demonbreun's saloon is just to the left of the awning in the middle of the block of shops at the back of this historical photo of the Public Square. *Metro Archives.*

a still-visible bluff cave along the Cumberland River. The family name later became Anglicized.

Bynum Demonbreun's saloon on the south side of Nashville's Public Square, opposite the courthouse, appears in city directories at least as early as 1889, when it was two doors down at 109 Public Square. Both there and at 113, he apparently lived in residential space above the saloon, something once common for shopkeepers.

Demonbreun's token, designed to encourage patrons to spend more than its worth, has been a common promotional item, past and present. The current Boscos Nashville Brewing Co. on Twenty-first Avenue South has issued a wooden one in recent years good for a free beer.

In B.R. Demonbreun's time, he faced great competition. By 1899, when he was in a three-story building at 113 Public Square, his saloon was one of 156 listed in the city directory. By contrast, only 57 restaurants were listed.

The easy availability of intoxicating drink and its effects on the Nashville citizenry eventually spawned an opposition movement. A "moral wave" gained strength among church groups and others in the first years of the twentieth century, targeting both strong drink and gambling. Even in earlier decades,

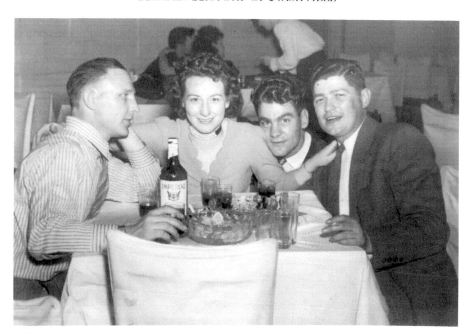

Patrons enjoy drinks at Club Forrest on Bransford Avenue in this photo, likely from the late 1940s. The club was closed by the City of Berry Hill in 1950. *Nashville Nite Club Photo Service.*

the temperance movement was viewed by business and agriculture industry leaders as a way to improve working habits among the laboring class.

"Before and after the Civil War and into the 20th century, southern leaders wanted to deny liquor to blacks and poor whites out of fear that alcohol would inflame passions and increase crime," Tennessee Tech University historian Calvin Dickinson wrote.

In late November 1908, the Anti-Saloon League and the Women's Christian Temperance Union met to join forces by organizing the Temperance League. Politicians and newspapers took sides.

Democratic governor Malcolm R. Patterson responded to the growing movement by sending the entire legislature a message in January 1909: "Prohibition is profoundly wrong as a governmental policy, and in a country where the largest measure of freedom is accorded, it becomes intolerable."

Legislators didn't listen. The same month, prohibition passed in the state Senate and House and withstood the governor's veto. Manufacture of liquor also became illegal in the state that February, with all distilleries and breweries required to close at midnight on December 31, 1909.

With so many Nashville saloonkeepers facing economic ruin, a businessmen's group formed to help them find other jobs.

Demonbreun's saloon, along with most of the others, suddenly appeared in the city directory under a different heading: "Soft Drinks." Few could raise even the rent money off that market. The new directory heading was soon missing entirely.

Access to intoxicating beverage didn't disappear but instead went underground. Nashville's bootleggers and basement and back alley speakeasy restaurants and clubs filled the void. They thrived—closed only on Sundays and bothered by only occasional police raids—until prohibition was lifted in Nashville in 1912.

Demonbreun's name had disappeared from the city directory by 1912, possibly indicating his retirement. He died in July 1920 at age fifty-nine, according to Demonbreun family researchers.

"National prohibition did not work in Tennessee in the 1920s (repealed in 1933) any better than state prohibition had since 1909," Dickinson observed.

Demonbreun's old saloon space opposite the Davidson County Courthouse lived on in city commerce. By 1924, it had become a newsstand run by Carl Zibart and his brother. They later became well known for their long-operating bookshop on Church Street.

By 1938, the little building housed a fruit stand operated by John J. Hill. Finally, the address served a series of liquor stores: Jonas Taylor's in 1940,

Bradley's in 1941, Matt's in 1942 and ultimately Sol's Liquor Store from 1944 to 1970.

The entire block was vacated by 1971 and razed by 1973 in Nashville's push for urban renewal around the courthouse. Virtually all of the distinctive Italianate buildings, many dating from the 1850s, that surrounded the once-crowded Public Square met the same fate. Their ornate stone and brick fronts are a fading memory to some but are unknown to many current Nashvillians.

STREAKING THROUGH THE 1970S

A story involving my grandfather as a 17-year-old, Thomas Dozier, was printed on Page 1 of the Nashville Tennessean *on Aug. 3, 1909. The headline was "Disrobed Runner Makes Commotion on Church Street." I believe "Papa Dozier" has been described as Nashville's first "streaker." Is this possible?*
—*Bonny Briney, Madison, Tennessee*

It's doubtful that anyone could document an older case of this fad, which is mostly recalled today from its wild popularity in the spring of 1974. Few who heard it can forget Ray Stevens's novelty song that year, "The Streak." ("Close your eyes, Ethel…") Thanks to Stevens's local music industry ties, the song got radio airplay in Nashville a week before anywhere else. By 1981, it had sold four million copies.

From Vanderbilt University to the stage of the Opry House, from Broadway to the corridors of the airport terminal, Nashvillians saw many flashes of 1970s flesh.

Streaking started largely on college campuses and called for abandoning clothes for a mad naked dash through a public spot. It spread across the country in a variety of venues. A live national broadcast of the Academy Awards show flashed a streaker across the nation's TV sets decades before Janet Jackson's wardrobe malfunction.

Locally, participants got both media exposure and sometimes public censure with fines and jail time for indecent exposure.

Consider the case of carpenter Daniel S. Majors, age twenty-one, who got a notion to "vertically" streak up the five-hundred-foot WDCN-TV broadcast tower behind his residence near the hill along Fifteenth Avenue

South, where Metro's emergency communications tower now stands. A pint of tequila beforehand had loosened his inhibitions.

Majors had reached the tower's first platform when a crowd below, thinking it must be a suicide mission, urged him to climb down. Police were waiting. The June 30, 1974 stunt cost him $62.50 later in court.

"We were partying one night and it seemed like the thing to do at the time," Majors, recently of Franklin, recalled. "The policeman's wife gave me a towel. My boss gave me a $2-an-hour raise the next day. He said he appreciated people who did crazy things."

Other 1974 Nashville incidents included:

- Vanderbilt streakings by late April, when three or four male students shed their clothes for a race through Carmichael Towers, and March 1, when six scholars wearing only tennis shoes sprinted in front of dorms at Twenty-fourth Avenue and busy West End.
- two students from Memphis State University arrested on March 8 for streaking in only their shoes and socks near the Channel 5 studios on James Robertson Parkway. They had been invited to Nashville for a TV taping about streaking by Channel 5 late-night talk show host Stanley Siegel.
- on March 11, a man shot in the foot in Printers Alley on an ill-fated streaking "challenge." It was the early morning hours when his friends abandoned him without pants and an alley club patron took umbrage at his state of T-shirt-only undress.
- David Holland, age twenty-five, charged on March 14 with streaking onstage at the Backstage, 102 Third Avenue North, just as the Mercy Blues were about to begin their act.
- by the end of March, the Soviet news agency Tass condemning streaking as evidence of the decline of youth under Western capitalism, and Tennessee legislator Representative Benny Stafford (R-Lenoir City) calling for a bill to prohibit even partial nudity. "Streaking is the most indecent and immoral thing. It brings this country one step closer to the dogs," Stafford was quoted as saying.
- by August, professionals were using the trend to streak Metro Airport (Kelly Holiday/Pamela Lapree, twenty-three, an exotic dancer at the Red Lion Lounge) and parade naked down Third Avenue North toward Broadway (Joyce Moore and Renee Dorton, both twenty-two and employees of the Magic Touch Massage Parlor).

In May 1975, a Linda Ronstadt concert before a capacity crowd at the Opry House got a bonus performance from a streaker who dashed behind Ronstadt before being ushered out by security.

The 1909 incident might seem a bit tame by twentieth-century standards. Subheadlines on the front page then were: "Night-Shirted Man Bears Down on Throng in Nashville's Great White Way. Name was Tom Dozier. North Nashville Youngster Ends Hilarity by Eating Matches in Cell. From hospital window jump begins marathon that draws growing band of pursuers—escapes."

It appears that Thomas Dozier (1891–1949) was "barefooted and clad only in a clinging nightshirt of the tube shape" when he ran downtown "with all the strength his athletic legs could carry him…his shirt ends flapping in the breezes against the skyline."

He dashed onto Church Street from an alley next to McKendree Methodist Church and "for a brief space held the riveted attention of the stream of passersby that throng there between 10 and 11 o'clock" before passing the "full glare" of electric lights and being "swallowed up in the darkness."

"The night-shirted freak was lost to view by the time the pursuers reached the Capitol grounds," the newspaper account said. It was described as "the rarest occurrence" to spectators "since Marathon races grew fashionable."

As it turned out, Tom had been locked up for drunkenness and pretended to swallow matches he had with him. He was taken to the hospital, where he jumped fifteen feet from a second-story window and sprinted seminaked for home in North Nashville.

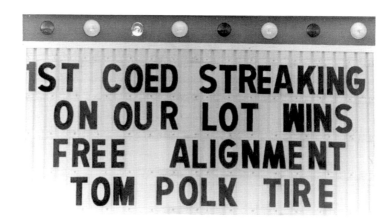

A sign at 125 Twelfth Avenue South teases young Nashville ladies during the streaking fad of 1974. *Kit Luce*, The Tennessean.

GERST, THE BREW THAT MADE NASHVILLE FAMOUS

I inherited my great-great-aunt's scrapbooks…In one is a postcard of the William Gerst Brewing Co., Nashville. The postmark is Aug. 7, 1911…Where was this brewery located? According to the postcard, it was a very large company and sprawled over several blocks. Are any of these buildings still standing?
— *A.M. Campbell, Spring Hill, Tennessee*

Many Nashvillians still recognize the Gerst name from the Gerst Haus Restaurant, now in its third location at 301 Woodland Street in east Nashville, near the Titans' Coliseum. While the popular German-style eatery features Gerst beer on its long libation list, the latest brew is now made by Pittsburgh (Pennsylvania) Brewing Co. and shipped here. Earlier, the name was licensed to an Evansville, Indiana brewery that also sold its product in Nashville.

Neither used the original recipe. The current Gerst is only on tap and only available in Tennessee. The real Nashville Gerst beer evaporated in 1954, when the local factory closed after a celebrated local brewing history dating back to 1890. The impressively large plant took up about five acres and multiple addresses at 823–887 South High Street, now Sixth Avenue South, just inside downtown's southern interstate loop.

In its heyday, Gerst was probably the best-known Nashville beer. The factory included malt houses, a bottling works, ice works, stables and a cooperage section where barrels for its lager and pilsner were assembled from wooden staves and metal bands.

The operation started as Moerlein-Gerst Brewing Co., a partnership of two German-born men from Cincinnati, Ohio—William Gerst (who moved to Nashville about 1890) and Christian Moerlein. Moerlein-Gerst won prizes when its beer was featured at the Tennessee Centennial Exposition in 1897 (now the site of Nashville's Centennial Park), as well as two years earlier at the Cotton States Exhibition in Atlanta.

Gerst's 1888 Cincinnati brew master diploma hangs today in the restaurant, successor of the one started in 1955 by a granddaughter of the family near the Public Square. Gerst later bought out Moerlein and dropped the name. Gerst beer was sold in much of the South, including Tennessee, southern Kentucky, Alabama and Arkansas.

The brewery originally featured "machines of the Delavergne patent for creating artificial refrigeration" and "a capacity for the production of 100,000

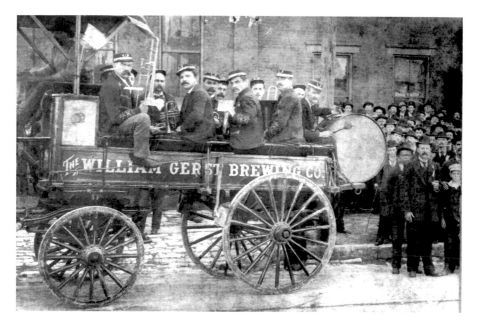

Nashville's Gerst Brewing Co. had little reason for a band to play during Prohibition. The 1890s firm closed in February 1954. *The Tennessean file.*

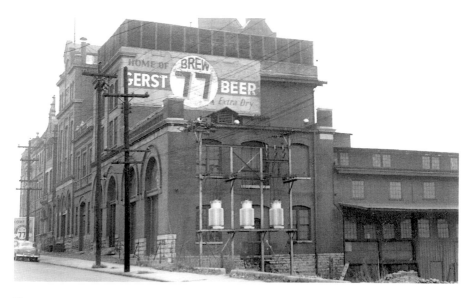

The main buildings of the Gerst Brewing Co. in downtown Nashville fronted Sixth Avenue South, just inside what is now the south interstate loop. *Elred Reaney*, The Tennessean.

barrels a year and the bottling of 2,000 dozen a day," an 1891 booklet on Nashville industry said. Production was eventually 200,000 barrels annually, made by up to two hundred lucky workers, who, according to one account, were allowed to sip samples throughout their workdays.

At one point, Gerst bottled a high-grade "Old Jug Lager" in jugs imported from Glasgow, Scotland. Its crockery containers were similar to those used by Moerlein in Cincinnati. During Prohibition (1919–33), Gerst produced "near beer."

Part of the original Gerst plant was demolished in 1963, but the three-floor bottling plant lingered. An insulation company was using much of it until a disastrous 1992 fire—visible from as far away as Williamson County—reduced it to rubble. Much of the site in current times has housed the Thomas Nelson Warehouse, 601 Ash Street.

One old brewery ad, clearly visible until recently, was painted on a brick building just south of Lafayette Street on the west side of Second Avenue South. Like the brewery itself, the name "Gerst" finally faded away, but the word "pilsner" lingered.

LEGAL PROSTITUTION IN NASHVILLE?

I saw a portion of a documentary, Sex in the Civil War, *shown on* The History Channel. *It stated that Nashville was the first city in the U.S. to have legalized prostitution—during the Union Army's occupation of Nashville. As a response to the high percentage of Union soldiers with venereal diseases, prostitution was made legal, with weekly checkups for the prostitutes. Do you have any more information on this?*

—Scoville Walker, former Nashvillian, Atlanta, Georgia

Nashville has not traditionally been associated with bold social experiments. This one appears to have been a strange but true wartime exception.

After its 1862 occupation by Union forces, Nashville saw 100,000 Federal troops passing through in less than a year for training before being sent to battle. Some were eventually buried here, and many received treatment at Nashville's twenty-three military hospitals.

With so many young men around, an increase in sexual activity could be expected. Many were headed to what they knew would be war deprivations of all sorts, if not likely death or dismemberment. A segment of Nashville's population rose to meet this demand.

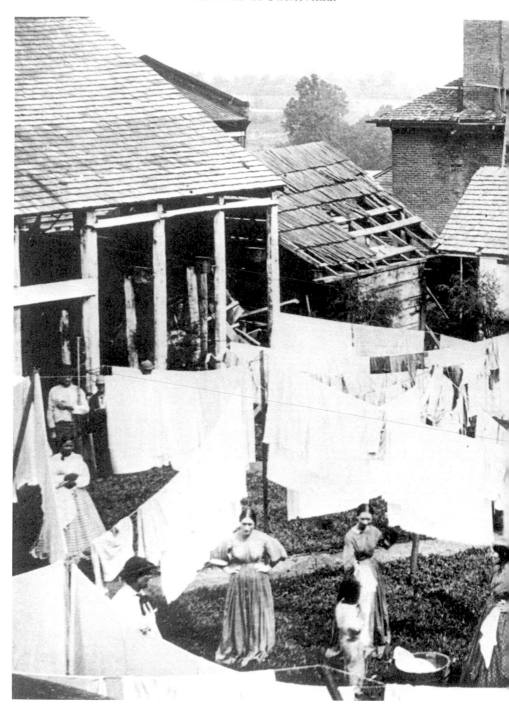

This photo was labeled "Nashville, Hospital laundry yard, July 1863." Some historians suggest that it shows a special hospital to treat diseased prostitutes. *National Archives.*

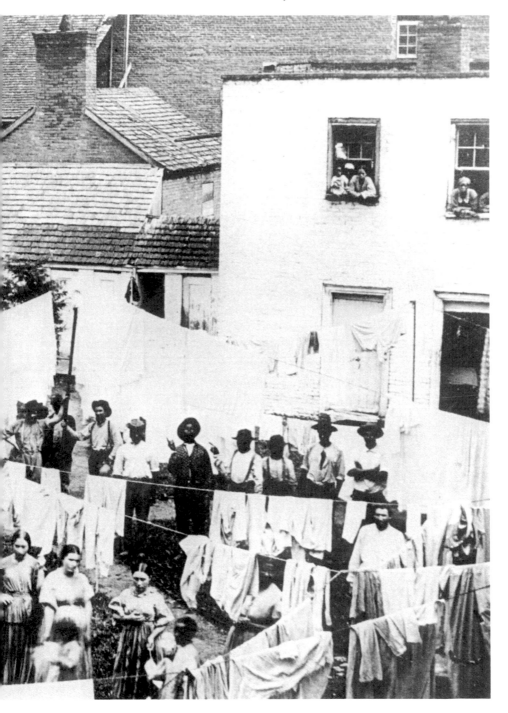

Nashville's 1860 census was different from most in that enumerators took it upon themselves to document prostitution. While the tally probably left out scores of those so employed, the census that year showed 207 professionals "not reluctant to call themselves what they really were." They ranged in age from fifteen to fifty-nine, but the mean age was twenty-three.

The largest house, at 101–103 North Front Street (now First Avenue), was near the steamboat landing where most city visitors arrived. Run by Rebecca and Eliza Higgins, the house had twenty-eight residents, seventeen of whom were prostitutes. Among the rest were a carpenter, a brick mason and eight children.

Total value of this out-of-the-ordinary property, including furnishings, was listed at $25,500—then quite a respectable sum. Most of the sixty-nine houses of ill repute were modest operations of one to three women.

By wartime, many more Nashville women had entered the profession, some forced by dire economic circumstance and others by choice. Estimates have ranged to above fifteen hundred.

With their activities came rampant spread of disease. Syphilis in those days was often fatal, as no reliable cure was known. One drastic measure recommended was injection of salts of mercury—highly toxic and carrying its own risks.

Alarmed Union military officials first tried solving the problem by rounding up prostitutes and shipping them under guard by train to Louisville, Kentucky. Most eventually returned but faced another roundup involving a chartered river steamer. During the month of that river cruise, a large number of black women had helped meet the unfilled demand with their own flourishing trade.

In desperation, the military decided to license the prostitutes in hopes of controlling their health and preventing the spread of venereal disease to soldiers. The deadline for them to report for testing was August 20, 1863.

Those presenting a "surgeon's certificate" and paying five dollars got "a license to practice their profession." Those caught without one were subject to a minimum thirty days in the workhouse. By April 30, 1864, at least 352 women had been licensed. Medical reexaminations were required every ten to fourteen days.

The soldiers were also targeted for treatment. By the end of 1864, 2,330 of them had passed through Nashville's "Soldier's Syphilitic Hospital." Thanks to Nashville's legalization of prostitution, only 30 of the first 999 admitted had contracted disease.

The History Channel has produced two programs on this topic: *Sex* (and *More Sex*) *in the Civil War*. Tapes of both are still sold through the A&E Television Network.

As a side note, some have wondered whether the Union's Major General Joseph Hooker was really the source of the term "hooker." General Hooker was in Chattanooga at one point, helping take Lookout Mountain. He was known as a leader popular with his men, as well as with the ladies of the night. In reality, this term for prostitutes appears to have predated him by many years. At the same time, his name is said to have added to its widespread use after the war.

LINGERING OR LOST

Mansions, Fires and Schools

PRESIDENT POLK'S DOWNTOWN MANSION VANISHES

I saw a landmark history sign in downtown Nashville where James Polk's house used to be. My question is why someone decided to tear down the house during that time? I don't understand why someone would demolish the house that used to be home of a president of the United States.

—John Evans, Hendersonville, Tennessee

Some historians say it comes down to one word: greed. Under different circumstances, the state of Tennessee would still have the presidential mansion as a historic site and tourism asset, something like an urban version of Polk's friend Andrew Jackson's Hermitage. Instead, we have a motel, a condominium building and a couple of modest memorial plaques where the house once stood.

James K. Polk (1795–1849), a talented lawyer, certainly didn't plan it that way. The president wrote what he felt was an ironclad will to preserve his house (built about 1819 for Felix Grundy, under whom Polk studied law) and his tomb on that site for future generations. His attempt to help some of his remaining relatives after his death proved to be the problem.

Polk specified that the property was to pass into state ownership after his widow's death. The flawed provision in his bequest allowed unspecified

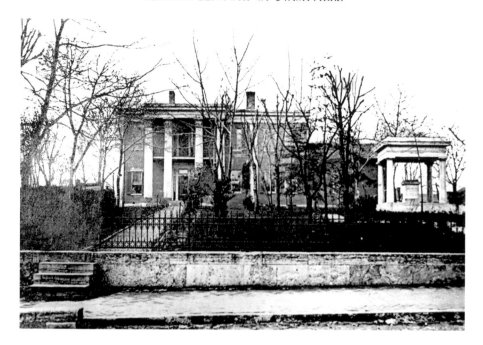

President James K. Polk's home fronted on Seventh Avenue at Union Street, where a motel and a condominium are now. His tomb was moved to the state capitol grounds. *The Tennessean file.*

relations with the name of Polk to live in the house "if there be such a person who shall be deemed worthy, and a proper person to occupy the same."

When Sarah Polk died in 1891, forty-two years after her husband's death in the house, fifty-five litigants came forward to challenge the will in court.

The Polks had no children. These were primarily the sons and daughters of the president's long-dead brothers and sisters who wanted to sell the land and divide the proceeds. They won in 1893, based on the legal difficulty of establishing who might be deemed "worthy" and "proper" to live there.

In 1898, the state sold the house for $20,500, or about $373 per plaintiff if it had been divided equally. It wasn't, and some kin got shares as tiny as 1/758th. The buyer, Jacob M. Dickinson of Chicago, sold the house in 1900 to out-of-town developers. They demolished Polk Place in 1901.

Commercial structures were later built there, including a YWCA and two apartment buildings, Polk Flats and the still-standing Watauga condominiums, formerly apartments. The tomb of President Polk and his wife was moved in 1893 to the northeast side of the state capitol grounds, where it remains today, somewhat hidden from view.

Polk Flats, a unique but austere apartment building, provided residents of its forty-two units with great downtown views at a convenient location. It was demolished in 1947 by Texas lessees to make way for a parking lot. Part of that decision had to do with rent controls imposed in the period after World War II. The parking lot gave way in 1960 to a motel, now a Best Western but previously a Days Inn, the Golden Eagle and the Downtowner Motor Inn.

In 1979, Mayor Richard Fulton proposed acquiring and razing buildings on the site to construct a replica of the Polk home. Nothing came of that idea. So Middle Tennessee's primary remaining physical ties to Polk are the president's tomb and his boyhood home in Columbia, Tennessee.

FIREHOUSES AS HISTORIC LANDMARKS

What can you tell me about the firehouse on 21st Avenue South near Blair Boulevard?
—Jon Bailey, Nashville, Tennessee

The modest little brick fire station at 2219 Twenty-first Avenue South is seen by thousands of motorists on the busy route between downtown and Green Hills. Few of them realize that it is actually the second-oldest Nashville fire hall still in use from the time it opened. The oldest, at 1600 Holly Street in east Nashville, is larger and more ornate, dating to 1914.

The Holly Street facility came into service only two years after the 1912 debut of Nashville's first three "auto fire trucks," or self-powered fire engines. They cost $9,000 each but were rated at sixty miles per hour "up hill and down." The beloved horses that had always pulled fire equipment began a phase of gradual "lay off."

But Engine Co. 16 on Twenty-first, with its single fire engine—and no space for another in its single bay—is a landmark in its own right.

The site was previously home to Garrett's Lunch Wagon, operated by William Garrett until about 1930, city directories indicate. It is around a corner from the present Brown's Diner in a converted streetcar, so the culinary tradition remains nearby.

The city bought the site on July 16, 1929, and completed the fire station building the next year, according to research by the Metro Historical Commission. The address may have encompassed more property over the years, since city directories show the fire hall sharing it with the Great A&P

Tea Co. in 1937, John W. Beard's dry cleaners in 1940 and Meador & Heise Pharmacy in the early 1950s.

The building's architect was a neighborhood resident, George D. Waller (1883–1971), then a member of the local architectural firm of Christian A. Asmus (1865–1954), according to a history of the Hillsboro–West End area.

Waller designed several of the mid-state area's schools, churches and residences, including the 1937 East Junior High (now part of East Literature Magnet School). The style he picked for the fire hall was Tudor Revival, reflecting nearby homes.

In 1936, the former *Nashville Banner* published a fire department history article saying that the fire force had 240 men and officers, twenty-two pieces of firefighting "apparatus" and five replacement fire halls that had been added within the previous year.

Other small fire stations in the city have been adapted to new uses over recent decades. A similar one at 1312 Third Avenue North, known by 1937 as "George Swint Hall" for Engine Co. 1, was once used as offices for the Soil Conservation Service.

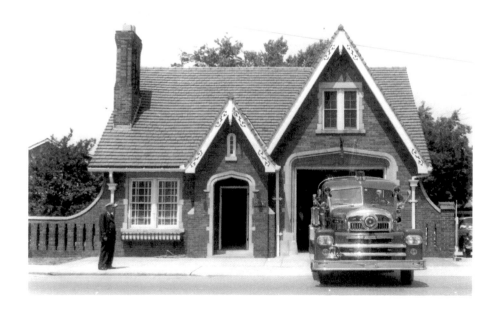

Fire Engine Co. 16 at 2219 Twenty-first Avenue South has always had only one engine. Here, in 1960, is its new one with a "closed cab" to shelter riders. *Metro Archives.*

By early 2005, before a more recent renovation project that added an adjacent annex for the fire engine bay, Engine Co. 16's yellow brick fireplace was covered over to provide space in the tight quarters for a computer terminal. The original built-in bookcases on each side of it still housed a library.

In May 1960, the station got the first of Nashville's five one-thousand-gallon pumpers. Their special feature, news accounts said, was a "closed cab that will accommodate all firemen riding on the engine, protecting them from the weather."

The station was listed on the National Register of Historic Places in 1993 as part of the Hillsboro–West End Historic District. In 1990, a plaque was installed naming the building in honor of Frank J. Quinn, fire chief from 1971 to 1974.

In front of the station, another historical marker commemorates Hillsboro Toll Gate No. 1, which operated a few yards away until 1903. The Nashville and Hillsboro Turnpike Co., started in 1848, charged fees—ranging from three cents for a horse or mule to twenty-five cents for meat cattle or a carriage drawn by a pair of horses or mules—to travel an improved "macadamized" road toward Franklin.

STAHLMAN BUILDING SURVIVES A CENTURY

My grandfather left home at the age of 13 in 1908 to escape his abusive father. He spent his first night away from home in the Western Union office of the Stahlman Building. I didn't know the Stahlman had been around that long. Can you give some background and insight about the history of that building?
—*Sharon Smith, Hendersonville, Tennessee*

The twelve-story Stahlman Building, now residential apartments, opened in 1907 at Third Avenue and Union Street as Nashville's second "skyscraper." It followed by a matter of months the debut of the equally tall J.C. Bradford Building at Fourth and Church Street, now a Courtyard by Marriott hotel.

Unusually, the Stahlman Building has kept its original name throughout its century of use. The other structure went through a succession from First National Bank to Independent Life to Third National Bank to Bradford.

The Stahlman was described as the first building in the city to have elevators—six of them—which were both fast and reliable. Dials for the

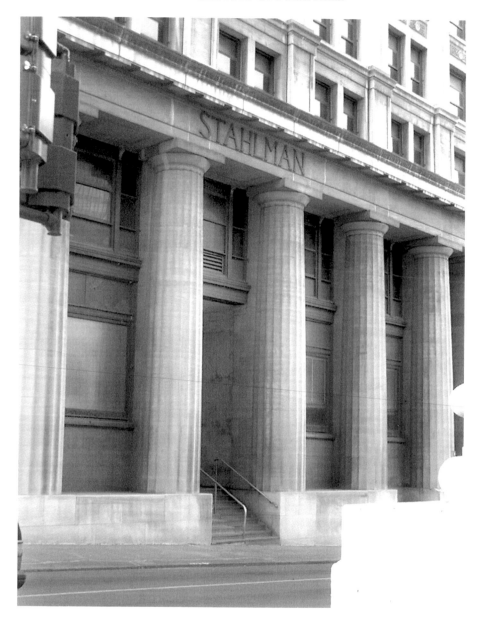

The 1907 Stahlman Building has kept its name through a succession of owners up to its present use as downtown apartments. *George Zepp*, The Tennessean.

original ones are still visible on its second floor. It was also one of the first Nashville office buildings to have some built-in car parking, just as the automobile was beginning to catch on.

By 1908, investment banker John T. Landis had an office on the Stahlman's ground floor. Crippled from a childhood fall, Landis was an early enthusiast of the automobile. His White Steamer was given a spot near his office in a drive-in garage facing Union Street. The garage later became the building's post office branch.

The 1907 city directory featured a full-page sketch of the building, showing only horse-drawn vehicles outside, and gave details of its features. It cost $1,050,000 and boasted 430 offices, along with three "banking rooms." Typical office rent was listed at $12 to $25 monthly. For that price, tenants got space in a structure that was "massive and elegant in all of its appointments—equal to (the) best in New York." Finishes included "Italian marble, mahogany and genuine bronze."

E.B. Stahlman. The Tennessean *file*.

The namesake of the building was newspaper publisher Edward Bushrod Stahlman (1843–1930), who in the 1880s acquired the now defunct *Nashville Banner*. Despite a meager grade-school education in his native Germany, Stahlman worked his way to prosperity. He was among the founders of the Associated Press and the Nashville YMCA. His Mecklenberg Realty Co., named after the German area where he was born, built the Stahlman Building.

Thanks to its proximity to the courthouse, the Stahlman was always a favorite home for lawyers. It had at least three in 1908, but by 2000 there were many more, including thirty-seven in the Metro Public Defenders Office alone.

Attorney Charles Galbreath had his office there continuously from 1949, except for a period from 1968 to 1978, when he served as a Tennessee Court of Criminal Appeals judge.

Many Nashvillians recall the building for the giant neon radio station call letters on its rooftop since the 1960s promoting WKDA and WKDF.

Metro government bought the Stahlman in 1971, after Mayor Beverly Briley called it "one of the real downtown landmarks." It housed civil courts, as well as public defenders, for a time, but the last of the tenants had moved out by October 2003.

The metro council voted in 2001 to transfer the Stahlman to the Metro Development and Housing Agency to oversee its conversion into apartments. That project was completed by developers Bert Mathews and Marty Heflin. The plan by Everton Oglesby Architects kept the building's art deco features added over the years, as well as restoring the grandeur of its glass-roofed central light well.

HILLSBORO HIGH SCHOOL GOES UP IN FLAMES

I noted on the Web site classmates.com in the section on Hillsboro High School that there was a fire at the school in the early 1950s. My family moved to Nashville after the fire and I recall my sister...had classes at Belmont College for almost two years while the "new" Hillsboro was being rebuilt. What more is there to the story?

—*Matt Fleurs, Louisville, Kentucky*

As difficult as it is to believe today, Hillsboro was a rural Davidson County school when the art deco–designed building opened in 1939 with 164 students in grades nine through twelve. Its students lived in the suburban fringe communities between Bellevue and Antioch. Only a dozen graduates got diplomas that first year—6 boys and 6 girls.

With unrelenting residential development swelling the young population, a new school wing was nearing completion and just short of being put into use on October 31, 1952, when fire broke out about 2:00 a.m. The flames began in the main part of the building and leaped two hundred feet into the air. The T-shaped building burned until dawn.

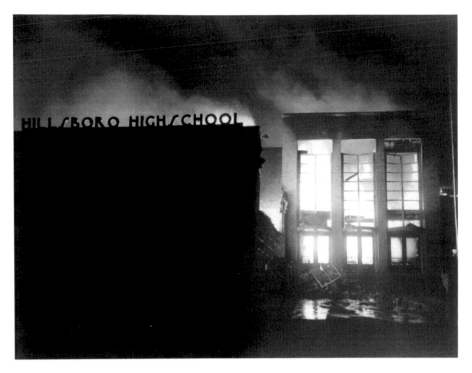

Smoke and flames highlight the Hillsboro High School name on the night of its catastrophic fire, October 31, 1952. *Metro Archives.*

"Firemen said they were pitifully handicapped because only one fire plug was located in the area—that one quarter of a mile from the school," *Tennessean* reporter Wayne Whitt wrote.

One anecdote concerns a book that miraculously survived the flames. As told by Matt Fleurs, whose question leads this account, it had been locked in the school safe by John Koen, Hillsboro's principal from 1941 to 1964.

English teacher Ruth Walker had assigned her students to write a report on *A Tale of Two Cities* by Charles Dickens, but one student's parents objected to the book and complained to Koen. While trying to work it out, Koen secured a copy of the book in his safe.

"Either the following night or that night the school burned down and that book was the only book to survive the fire," said Fleurs, who got the account from Walker more than a decade later.

On November 3, buses picked up Hillsboro students for an orientation meeting at Belmont College (now a university), their new home for two years while a new Hillsboro was being built. Unused buildings and spaces,

including basements of three Belmont dorms, were pressed into service for about thirty classrooms to accommodate the eight hundred pupils. Belmont was paid a rent of $5,100 a month under the arrangement.

Hillsboro administrators created offices in a house near the campus. Classes resumed on November 10 at Belmont, and homecoming festivities were held on schedule on November 14.

By early 1953, Hillsboro's sixty-two home economics students had been relocated to Belmont Methodist Church, which had a new kitchen. Plans were also made to occupy the Harris Art Studio, a two-story brick building near Belmont.

Officials initially hoped to have a new Hillsboro High building ready by the fall of 1953, but completion took a year longer. The school housed up to fifteen hundred students in 1967, before its ninth grade class was relocated.

The fire's cause was never determined, but no foul play was suspected, despite the fact that it broke out on Halloween morning.

The Hillsboro High destruction did raise public support for adding a dozen more fire hydrants near county schools in need of them, a young reporter by the name of John Seigenthaler wrote. Seigenthaler, now chairman emeritus of *The Tennessean*, mentioned that fact in writing about another 1952 blaze that destroyed the 1931 portion of Haynes Elementary School on Trinity Lane.

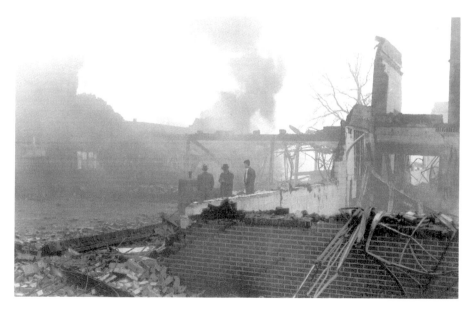

The 1939 Hillsboro High building was reduced to a shell by the next morning's light. Rebuilding took two years. *Metro Archives.*

Father Ryan, a Battlefield Chaplain and a School

What can you tell us about the Confederate chaplain Father Ryan? Was the school in Nashville named for him?

—Hi Brown, Foley, Alabama

Abram Joseph Ryan was a complex and tormented man with what we might today call many "issues." He also was the inspiration for the name of the 1929-dedicated Father Ryan High School here in Nashville.

As a Catholic "battlefield priest" in his twenties during the Civil War, Father Ryan was unquestionably brave as he administered to injured and dying soldiers in the midst of warfare. His right hand was injured in the Battle of Franklin.

As a man and a poet, he was either blessed or cursed with both a creative and emotional nature and a chronic distraction that now might be characterized as attention deficit disorder. He liked to begin card games with soldiers but usually wasn't focused enough to complete them, let alone win.

Father Ryan's most famous poem was dashed out on a scrap of paper and left behind, only to be discovered later by his former Knoxville landlady. As a result, "The Conquered Banner" was ultimately shared with the world beginning with its publication in a Nashville newspaper.

His poetic verses, published widely in American newspapers and in book form, helped him become known across America as a charismatic speaker. Ryan's star power on the inspirational lecture circuit was in its day close to that of Billy Graham in the following century.

But this long-haired man in black met a relatively early end before the age of fifty, after a life that included priestly work in Nashville, Clarksville, Knoxville and Memphis, among several other southern cities. He was a steadfast champion of the Confederacy, for which his brother fought and died in Kentucky. While some knew him as the "Poet-Priest of the Confederacy," the *Chicago Tribune* labeled him "the Traitor Priest."

Father Ryan later advanced national healing and rebuilding of the South. His work in the late 1870s to control typhoid fever deaths in Memphis helped that city get its first sewer system.

Legend and hyperbole, spread through America's long national delight in personality journalism, have corrupted much of his story. Separating fact and fiction is difficult. A comprehensive biography is still lacking.

Students enter the front of the old Father Ryan High School in May 1991. Its namesake was a Confederate battlefield chaplain. *Kats Barry*, The Tennessean.

Ryan, who died in 1886, was born about 1838 either in Maryland or Virginia to an Irish father and a Virginian mother. He was raised in St. Louis and schooled in Missouri, Pennsylvania and New York.

His ministry assignments while in Nashville were in Edgefield and also at St. Mary's Church, still standing downtown. Edgefield was then a separate suburb east of the Cumberland River, where Ryan served at what is now Holy Name parish.

Father Ryan High School, a private Catholic school now located at 700 Norwood Drive in the Oak Hill area, began on Elliston Place on the estate of Nashville's fourth mayor. It moved in 1991. A hotel and restaurant now occupy the previous school site, at Twenty-fourth Avenue North, not far from Vanderbilt University.

Colemere Site Becomes Ritzy Club, Restaurant

Do you know anything about the history of the New Orleans Manor mansion located on Murfreesboro Road?

—Jeanette S. Davenport, Lebanon, Tennessee

The tale of this former home that has been a restaurant for over thirty years near Nashville International Airport is tied directly to two other fascinating "country homes" now wiped away. One was designed in a unique style by the architect of Nashville's Parthenon. The other was fit for a king and, in fact, was on a 640-acre tract belonging to one.

Along the way, there was a French gardener-in-residence, a fancy fence that withstood a terrible war, a unique water tank, years of backroom political intrigue and even a demolition that seemed certain but never quite came about.

Nashvillians who ventured out long ago on Murfreesboro Pike knew that two of its crown jewels were the houses named Colemere (1893–1929) and Kingsley (1832–ca. 1959).

Colemere was built by Colonel E.W. Cole soon after his retirement as president of the Nashville, Chattanooga & St. Louis Railway. Architect William C. Smith drafted a unique but pleasing "confusion" of styles. Smith was the architect of Nashville's Parthenon replica and, earlier, Kirkland Hall at Vanderbilt University.

Colemere's seventeen-acre grounds included a grand limestone and iron gate leading up the drive to a porte-cochère where carriages could park under a roof in the front to protect passengers from the elements. Two oval side porches were distinctive features.

An October 1929 fire that destroyed the Colemere mansion led to construction on its site of a 1931 residence designed in the style of a Natchez, Mississippi mansion by Russell Hart, of the still existing Nashville architectural firm Hart, Freeland, Roberts. It was acquired by the city about 1940 and is now New Orleans Manor.

The building was earlier leased under city ownership for use as the private Colemere Club, a favorite hangout of the city's political set. That popular use probably put off its once "certain" demolition for airport expansion, forecast in a 1944 news article. Local politicos could meet people of importance at the city's airport and whisk them into its private rooms for wining, dining and discussion.

Among the celebrities of the era seen there were Andy Griffith, the Everly Brothers, opera singer Robert Merrill, Eddy Arnold, Red Foley, Charlton Heston and Senator Estes Kefauver.

As the Colemere Club (1948–73), it even had a rear upstairs room that could be entered from the outside for discrete wheeling and dealing. For years, its grounds were used for children's Easter egg hunts.

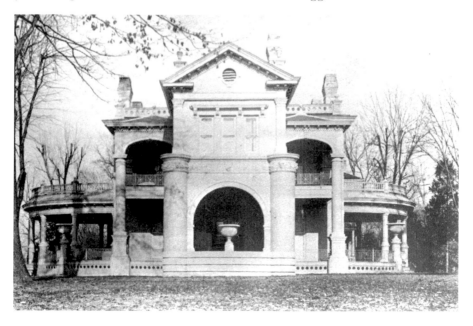

Colemere mansion was a landmark along Murfreesboro Pike until a fire destroyed it in 1929. *The Tennessean file.*

It became New Orleans Manor in 1977, when Iona Senecal and her husband leased it. Their buffet-style seafood restaurant caught fire in 1998 but was rebuilt and reopened within three weeks. The interior was renovated in 2008 under new management.

Across Murfreesboro Road from the 1893 Colemere mansion was Kingsley, built in 1832 for Nashville merchant Thomas Seawell King (1786–1851) on a 640-acre land grant.

The home went to banker Dempsey Weaver (1815–1880), King's son-in-law. The design for its front portico, an addition about 1860, has been attributed to Francis Strickland, son of the architect of the state capitol, William Strickland.

Weaver's love of gardening inspired him to hire a French gardener, best known locally only as "Monsieur Ravey," who oversaw the plantings of formal gardens and many trees. Ravey lived on the estate throughout the Civil War—and apparently even several years beyond his patron's death.

The Kingsley estate's ornate, hand-hewn cedar fence was said to be the only one between Nashville and Murfreesboro left standing by Federal troops during the Civil War. It remained intact until the widening of Murfreesboro Pike in the 1940s.

About 1870, a three-story water storage tank was added in the back of the house, disguised as a wood shake–covered early American blockhouse. Such structures once were used as lookouts for hostile Native Americans. This one was much taller than most original blockhouse designs and was an eye-catching feature for those lucky enough to tour the grounds.

Kingsley was featured in the novel *Supper at the Maxwell House*, a title that referred to Nashville's once premier hotel at the corner of Church Street and Fourth Avenue North, opposite the L&C Building.

The home's last private owner—after five generations—was the remarkable Lebanon, Tennessee–born widow Edna Beard Harris, nicknamed "Chico." She was a major YWCA worker, avid golfer, horse lover, rose grower, meat curer and fancy fowl raiser whose virtuosity on the violin was featured at about one hundred Nashville weddings, as well as with the Nashville Symphony. Her love of music led her to a 1955 opera outing to New York City, where she died in a bed at the Sheraton-Astor Hotel, "stricken in her sleep" before a physician could arrive, according to her Nashville newspaper obituaries.

Harris's husband, Weaver Harris, had died in 1937. The city bought Kingsley in early 1946 for eventual airport expansion. It was leased in 1947 to the First Baptist Church for use as the Fidelis Home for the Elderly and then demolished about 1959.

Nashville Notables

Performers, Pilot and Writers

A *Peter Pan* Original at Ward-Belmont

Mary Martin, who was from Texas and known as the Peter Pan, was the mother of actor Larry Hagman. She attended "a Nashville finishing school" for a few months, I read in a brief bio. Any idea what school it was?
—*Bryce Martin, Spring Hill, Tennessee*

Mary Martin's trip from Texas to Tennessee wasn't her idea. Her parents thought a dose of girls' schooling was what she needed at age sixteen.

They picked a Nashville finishing school designed to produce bright and proper young ladies. Coincidentally, it was educating another world-class performer-to-be about the same time: 1932 grad Sarah Colley Cannon, later to become the premier country comedienne Minnie Pearl (1912–1996).

The school was Ward-Belmont College, then on the same campus that is now Belmont University. Mary arrived there in 1930.

"I finished it all right—in 2½ months," she wrote in her biography.

She developed a crush at age fourteen on young Ben Hagman. Her father, a lawyer in Weatherford, Texas, and her mother, once a violin teacher at a seminary, wanted to cool the growing romance once Mary was out of high school.

Ward-Belmont College in 1951, its final year, looked much the same when it was home to developing theatre icon Mary Martin in 1930. *The Tennessean file.*

Ward-Belmont wasn't so bad, until Mary learned about all its rules.

"At first I adored it, too. I made a lot of friends, and I sang at every club function anybody ever gave," she wrote. "I wasn't accustomed to strict rules about makeup, to limited dating, hours on campus, chaperones all over the place."

Her later knack for performing was shaped by the head of the school's music department, Dr. Stetson Humphrey, and his wife, Irene, who had sung at the La Scala theatre in Milan.

In English class, her essay on Benjamin Franklin gave the teacher a lesson for the other girls on plagiarism: "I didn't even know what the word meant until Bessie Mae explained it to me."

Her mother was so taken by Mary's complaints of homesickness that she drove Ben Hagman, age twenty-one, to Nashville to comfort her.

"Then Ben and I talked Mother into letting us get married," Martin recalled. "I must be frank: I wanted to get out of Ward-Belmont, and I did not want to write that term paper. I never did, as it turned out."

The trio headed north for Hopkinsville, Kentucky, a state where marriage age wasn't an issue. "How hillbilly can you get?" Martin wrote later.

The two wed in an Episcopal church on November 3, 1930. The school learned of this, expelled Martin and sent her home to Texas on a train from Union Station, the same way she arrived.

Son Larry was born on September 21, 1931. His mother was seventeen. The newborn actor was later to captivate his own audience on the 1980s TV show *Dallas*. His parents divorced in 1935.

Back in Texas, Martin used a Fort Worth radio audition as a springboard to become one of the great ladies of American musical theatre. In 1938, her Broadway debut gave her the Cole Porter song "My Heart Belongs to Daddy."

The roles rolled her way: *Peter Pan, South Pacific, Annie Get Your Gun, The Sound of Music, I Do! I Do!* Television followed in 1953. The *Peter Pan* telecast in 1955 drew 67.3 million viewers.

Former Ward-Belmont classmates turned up frequently backstage at various Mary Martin performances across the country.

Martin died of cancer at her California home in 1990, a month short of her seventy-seventh birthday.

Ward-Belmont, begun in 1913, folded amid debts in 1951, with sale of the campus to the Tennessee Baptist Convention. The Baptists' Belmont College, now a university, was born that year.

Former supporters of Ward-Belmont helped form Nashville's ongoing Harpeth Hall girls' school.

DELBERT MANN, A HOLLYWOOD ARTISTIC

Before going to Hollywood, to win within a very short time thereafter an Oscar as director of the year, Delbert Mann as a Vanderbilt University undergraduate worked at the Belcourt Theatre doing just whatever they would let him. What are some other facts about his Nashville connections that many people might not know?
—James R. Tuck, Nashville, Tennessee

Delbert Mann came to Nashville with his family in 1931, graduated from Vanderbilt University in 1941 and won the Academy Award as best director for his first motion picture, *Marty*, released in 1955.

Ernest Borgnine won his own Oscar in the film for his portrayal of a lonely Italian butcher in the Bronx who finds unexpected love with a shy

Delbert Mann and his wife, Ann Caroline Gillespie Mann, plus their two sons, David (left) and Fred, pay a visit to Nashville in 1956 between the director's jobs. *Jack Corn, The Tennessean.*

teacher. Paddy Chayefsky received an Oscar for the adapted screenplay, as did Harold Hecht for producing it.

It has been said that the black-and-white film's promotional budget of about $400,000 exceeded the cost to make it, about $343,000. Mann's TV version of the same drama, with actor Rod Steiger, aired two years before the film.

Mann directed more big-name stars than can be named here—including Deborah Kerr, David Niven, Borgnine and five others—to Oscar nominations.

Mann, who died at age eighty-seven in 2007, ultimately did more work for TV than film, from the "golden age" of the medium on. His acclaimed versions of *Heidi*, *David Copperfield* and *Jane Eyre* came before such classic stories found an outlet in public television.

One national writer described him as "one of those rare Hollywood directors more interested in artistic satisfaction than profits."

The Mann family contributed in many ways to Nashville after locating there so that Delbert Martin Mann Sr. could teach sociology at Scarritt College. Mann's parents lived at 215 Lauderdale Road, off West End Avenue, until their deaths in the 1960s. His mother, Ora Patton Mann, also a teacher,

served as chairman of the first Tennessee Commission on Children and had been a Nashville city school board member.

Young Delbert headed the Hume-Fogg High School Dramatic Club while attending classes there. He worked with Nashville's Community Playhouse in the summers of 1938–40.

"The whole atmosphere in Nashville was stimulating," he told *Tennessean* writer Louise Davis in 1955.

His wife, a Nashville native and Vanderbilt graduate, had worked as a reporter and feature writer for the *Nashville Banner* while Mann was serving as a bomber pilot on thirty-five European missions during World War II. Ann Caroline Mann died at age eighty in 2001.

Mann and his family of four children often returned from California to Nashville on vacations to see his parents. He also helped stage a few productions in the city.

In 1982, he directed Pearl Bailey in a live theatre TV telecast of Carson McCullers's *The Member of the Wedding* for NBC. It was staged at Polk Theatre in Nashville's Tennessee Performing Arts Center.

In 1993, he came out of retirement to direct a single performance at Vanderbilt of a one-actor drama called *The Memoirs of Abraham Lincoln*, starring his friend Granville Van Dusen.

Demonstrating his fondness for his alma mater and Nashville, Mann donated his personal papers to Vanderbilt's Heard Library in 1989.

CORNELIA FORT'S WARTIME SACRIFICE

I am reading Cornelia Fort's biography. She grew up in east Nashville on a farm/ estate called Fortland. There is a Fortland Drive that runs off Riverside Drive. Where was the house and…whatever happened to it?
 —*Judith Leathers, Dickson, Tennessee*

It was just after Christmas 1942 when Nashville aviation pioneer Cornelia Fort got the bad news about her beloved childhood home, Fortland. A December 27 telegram from a friend told her that defective wiring had sparked a fire, destroying the twenty-four-room mansion, although some ground-floor furnishings were removed.

"The white columns of Fortland were always in my heart, a place of refuge and return," she wrote her mother.

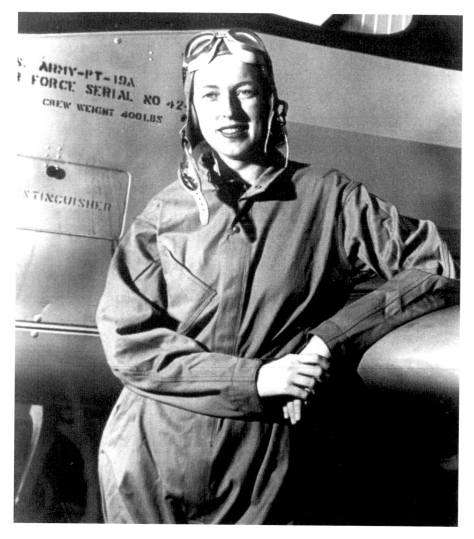

Cornelia Fort stands beside a PT-19 training airplane. The Nashville debutante-turned-pilot became the first Tennessee woman to die in World War II duty. *Nashville Room, Nashville Public Library.*

The house, dating to 1852, was located off Riverside Drive, east of Shelby Park. The current Fortland Drive follows generally what was once the grand entranceway to the 356-acre cattle farm estate of the Fort family.

Before her rise to the aviation record books, Cornelia had enjoyed "all the laughter of my youth" at the estate. There she had experienced fox hunts, lived among its fine furnishings and artworks and found "a tranquility that I shall never know again."

Her words proved prophetic. Three months later she was dead.

Fort's love for flying had been kindled just two years earlier. After her first solo flight in the spring of 1940, the 1939 Sarah Lawrence College graduate rushed home to describe it to her mother.

"How very nice, dear. Now you won't have to do that again," came the reply.

She did anyway. In June, she celebrated receiving her private pilot's license by flying over two thousand miles in the first week. In March 1941, she was rated as an instructor.

She was giving a flight lesson in Hawaii on December 7 that year when a military plane came so close that she had to pull away. She was shocked to see its Japanese markings. Minutes later, she spotted smoke rising from Pearl Harbor and then saw a swarm of other bombers. She quickly landed, with bullets peppering the runway in her path. World War II was underway.

Fort went on to join the Women's Auxiliary Ferrying Squadron, delivering newly built planes to military installations. Women pilots were used so that more men could remain in wartime combat roles. It was cold and exhausting work, often in open cockpits.

On one of those missions over Texas, something went terribly wrong. The family never got a definitive explanation, but Fort's plane was touched by another and went down on March 21, 1943. The other pilot was able to bail out, but Fort was killed.

Female pilots in her role were granted full military status retroactively in 1979, making Fort the first woman pilot to die on war duty in American history. She was twenty-four.

Today, the Cornelia Fort Airport in Nashville, opened in 1945 not far from her family's Fortland, helps keep her legacy alive.

Her will called for a bequest to Sarah Lawrence College for scholarships benefiting southern girls with "intellectual curiosity and wanderlust," plus another sum for her "dearly beloved dog Kevin."

TENNESSEE WILLIAMS'S
EARLY NASHVILLE DAYS

I have been told that the buildings on the southeast corner of Edgehill and 17th Avenue South in the Music Row area—presently a recording studio and formerly

Tony Alamo's church—were once an Episcopal church where the grandfather of Tennessee Williams was pastor. Does that check out?

—*Bob O'Gorman, Nashville, Tennessee*

Not only was it the noted playwright's grandfather's church, but also the brick rectory still standing next door was the home of Tennessee Williams himself for a year when he was young.

The late *Tennessean* feature writer Louise Davis uncovered some of the details in a rare interview with Williams in New York. It was 1957, shortly after the debut of the controversial Elia Kazan–directed movie made from his play *Baby Doll.*

"The South once had a way of life that I am just old enough to remember—a culture that had grace, elegance…an inbred culture…not a society based on money, as in the North. I write out of regret for that," Williams told Davis.

Davis talked to the playwright as he was overseeing preopening rehearsals for his *Orpheus Descending* on Broadway.

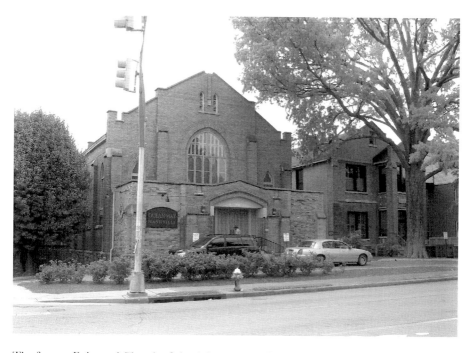

The former Episcopal Church of the Advent—now Ocean Way recording studio—was where famed playwright Tennessee Williams's grandfather was rector. Williams lived briefly in the rectory (right). *George Zepp.*

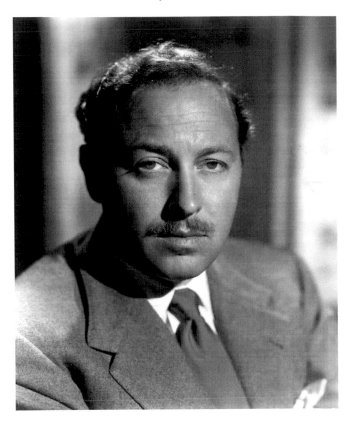

Tennessee Williams
The Tennessean file.

"I loved Nashville," he told her. "I remember so many things about it—picking flowers…a terrible thunderstorm that tore the awning off our porch…crying when my mother left me at kindergarten for the first time…And I had my first streetcar ride in Nashville."

Davis noted that it was Williams's "torrid play" *A Streetcar Named Desire* that helped boost his fame.

"What I am writing about is human nature," he told her. "I write about the South because I think the war between romanticism and the hostility to it is very sharp there."

He said some of the controversies over the rawness of his works— including *Cat on a Hot Tin Roof*—were misdirected because "there is a lot of violence in life."

His mother, Edwina Dakin Williams, told Davis in a telephone interview that her children made frequent visits to Centennial Park for picnic lunches with their African American nurse, Ozzie. Tom (Thomas Dakin Williams), as Tennessee was then called, was age three in that 1916–17 period.

"Ozzie would take us to the park on summer days and we would sit under the trees while she read us some ghost stories and made up others," the playwright recalled.

"As the rector's grandson, I observed the genteel South," he said of the period soon afterward when the family returned to Mississippi. "I got a more intimate view of human problems."

His grandfather, the Reverend Walter E. Dakin of Ohio, first came to Tennessee to attend the University of the South in Sewanee in 1895. Williams, who died in 1983, bequeathed the university about $10 million from his estate.

Dakin's Nashville church had its own intriguing past. It was an offshoot of Christ Church on Broadway, born from a dispute over the custom of pew rentals.

A few of the wealthy families who could afford the pew fees opposed the 1848 rector's proposal to abolish them. The Reverend Charles Tomes left in 1857 to found Church of the Advent at Seventh Avenue and Commerce Street—where the Renaissance Nashville Hotel now stands. Tomes died later the same year of typhoid fever, and the Civil War delayed the new church's completion until 1866.

The little church moved about 1910 to a new Gothic Revival building in the "suburbs," now on Music Row at 1200 Seventeenth Avenue South. In 1973, the Church of the Advent relocated to a new building in the Brentwood area, at 5501 Franklin Road.

The old church building on Seventeenth, designed by architect Robert Sharp, has been through a series of modern uses: a neighborhood center for the YMCA; in 1977, the Advent Theatre of the Tennessee Performing Arts Foundation; in 1981, the Alamo Foundation's Nashville headquarters and a videotaping center for evangelist Tony Alamo's TV shows; in 1993, the start of conversion by California investors into Ocean Way recording studios; and in 2001, acquisition by the present owner, Belmont University.

A 1991 fire damaged the rectory annex where Williams had lived, but the renovated rectory is still incorporated in Belmont's Ocean Way Studios for its School of Music Business.

VENTRILOQUIST EDGAR BERGEN'S UNKNOWN PROTÉGÉE

My mother was a resident of the Municipal Children's Home in Nashville because her father was a war veteran ill from alcohol addiction. Her name was Thelma Jean Graham. She was discovered by Edgar Bergen in 1940 while living at the home… and went to California to live as his protégée…He wanted to adopt her, but there were problems and this did not occur…Do you have any information on the home or on her?
—*Mary M. Ranson, Pass Christian, Mississippi*

Thelma Jean Graham was once known as Nashville's Cinderella, thanks to the interest the famous ventriloquist took in her. How it all happened was well documented in news accounts of the day, now largely forgotten.

The fairy tale story may have helped take Nashvillians' minds off the war in Europe. Thelma Jean shared the front page with headlines like "Hitler's Warplanes Circle London Area in 'Nuisance' Attack."

Bergen—his Swedish family's original name was Berggren—had become a nationally known favorite by 1940. He and the irascible dummy Charlie McCarthy were a big hit on radio and even made a few movies with comedian W.C. Fields. (His daughter, actor Candice Bergen, is known to later generations as the TV star of *Murphy Brown* and, later, *Boston Legal*.)

The former vaudeville ventriloquist's star was shining and his wealth was growing. An amateur pilot in California, he wanted his own airplane.

Like motion picture actor Jimmy Stewart and millionaire Howard Hughes, Bergen turned to Nashville's Stinson Aviation, later to become Vultee and Avco.

Bergen arrived in Nashville on July 25, 1940, on an American Airlines flight, to take delivery of a lightweight Stinson Model 105, one of about 535 built here. He had the silhouette of Charlie McCarthy painted on its tail.

"The reason I came here to get my ship was that I wanted to see how it's built and what goes into it," he told a newspaper reporter.

Hundreds of autograph-seekers greeted him at the airport. He was rushed to the Andrew Jackson Hotel for lunch and a short program. On the bill was a performance by Nashville's own Thelma Jean Graham, age twelve.

Thelma Jean's own arrival in Nashville was much less glamorous. She wandered into a Nashville bail bondsman's office, alone and neglected, clutching a shopping bag with something unusual. It was a little ventriloquist's dummy she had named Elmer. She asked where she could find the city jail.

"'I want to find my daddy,' the hazel-eyed child told the bondsman and a *Tennessean* reporter who happened to be present," an article in that newspaper recalled.

Local child welfare authorities were summoned. What they learned was shocking—the tale of a poor girl's strange life on the road with her father's traveling medicine show. Thelma Jean had been living with him in a little wooden shack without plumbing, mounted on a flatbed truck as they toured the country.

"Doctor Graham," or "Chief Lightning" as he was sometimes known, peddled elixirs promoted as good for what ailed you, about one dollar a bottle. He also pulled teeth for poor southerners who couldn't afford a dentist.

The crowds were drawn with entertainment. Part of that was Thelma Jean.

Her father had trained her to tap dance, walk a tightrope and sing. But the skill she eventually mastered best was throwing her voice.

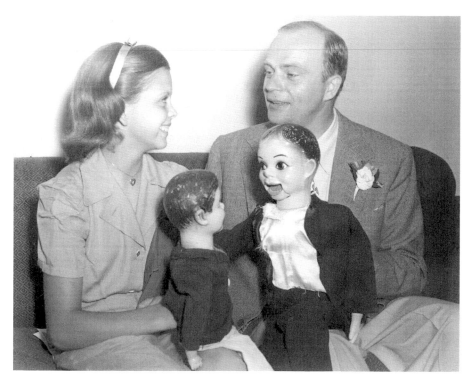

Ventriloquist Edgar Bergen lets a pal (not Charlie McCarthy, who stayed home) chat with Nashville's Thelma Jean Graham and her Elmer in 1940. *The Tennessean file.*

Most disturbing to officials in Nashville was the revelation that Thelma Jean's hard work in their vagabond life seemed mainly designed to finance her father's bouts of drinking in beer halls along the way. Thelma Jean was ordered to become a ward of Nashville's courts.

In those days, the Nashville Municipal Children's Home was the only logical place for a youngster in such a predicament. Built in 1926, it wasn't fancy. The grounds had a "formidable fence." The windows had bars. It got better later, but in Thelma Jean's day it couldn't have been too pleasant. It housed delinquent or "incorrigible" children, as well as those deserted or neglected.

Into that environment went Thelma Jean and Elmer, the little ten-dollar dummy she had found at a Memphis department store. While family members said she didn't make close friends among the other girls, Elmer became a hit there and at local civic clubs.

After viewing Thelma Jean's performance at the Andrew Jackson Hotel, Edgar Bergen flew back to California piloting his little Stinson.

Nashvillians rallied around Thelma Jean. A retailers' alliance donated a fancy wardrobe, assembled by a "style consultant." She was taken to shop for nice luggage.

She left Nashville by train from Union Station, clutching her little dummy, Elmer. She had just turned thirteen.

Bergen, thirty-five, already the star of radio shows and movies, had praised what he saw as Thelma Jean's natural talents. She was being described in the press as his first protégée. But it wasn't long before things began to change.

Rather than rush young Thelma Jean into the national spotlight, Bergen and his advisers decided that she needed more education. She was enrolled in Parnel Preparatory School for Girls in Whittier, California.

Her southern accent began to disappear. "But I can always get it back again if I need it," she told a reporter.

On weekends, she stayed at Bergen's home above Beverly Hills for personal instruction from the master. She began to call him "pops" and his mother "moms." She developed a special bond with his mother, possibly because her own had been absent from her life.

Bergen at that point was still a confirmed bachelor.

His daughter, Candice Bergen, wrote in her own biography that he was "a scholarly man, now in his late thirties, never married, who lived quietly and cleanly with his mother and his dummy and whose idea of a perfect Saturday was to stay home alone and spend hours poring over his suitcases of old magic tricks."

Bergen had a special ventriloquist's dummy made just for Thelma Jean, tailoring it to her own speech and personality. Actor Fred McMurray advised his friend Bergen about it.

A black boy with close-cropped hair and bib overalls, it was christened Andrew Jackson Lincoln Jones—the "Andrew Jackson" for the Nashville hotel where Bergen had discovered her during the lunch in his honor.

Her routine included dialogue and jokes that would now be viewed as drawing heavily on racial stereotyping. In that era, it wasn't an issue.

Bergen apparently tried to adopt Thelma Jean, but it never came about.

By that time, her troubled, war veteran father had found his way to California to reestablish contact. Her mother also reappeared. Both seemed to her intent on benefiting from her newfound connections.

The details of what happened next are not entirely clear. One report indicated that Bergen's manager was either not impressed with Thelma Jean or doubtful of the career value Bergen's best efforts on her behalf could have.

"One day his manager took Thelma into her office, opening a file drawer full of letters from wanna-be ventriloquists, people who would've died to be in Thelma's shoes," wrote Mississippi reporter John Fulmer. "She said 'Look at this. Out of all the people in the world, why did he have to pick you?'"

Back in Nashville after her Cinderella days, Thelma Jean first attended David Lipscomb School. Later, she was a student at Tennessee Industrial School.

Bergen did not marry until 1945. His bride, Candice's Alabama-born mother, was twenty at the time. He was forty. They had met the year before when she was in the audience for his radio show and were married in Mexico.

That year was also pivotal for Thelma Jean. She eloped with a young sailor, James D. Elliott. She was seventeen. He was eighteen. They married just across the state line in Franklin, Kentucky. She had chosen family over show business, possibly hoping she could still have both eventually.

As late as 1947, a *Tennessean* article told of Thelma Jean's plan to try a radio career. She was a guest on WSM, the well-known clear-channel station in Nashville. Ventriloquism on the radio had worked for Bergen. Perhaps it could for her, as well.

The photo published showed Thelma Jean balancing Andrew Jackson Lincoln Jones on one knee and her new baby boy on the other.

Even after her first marriage, she toured the West Coast and Canada with USO shows for a while, but she returned to make Nashville her home. In the end, family won out.

Her marriage to Elliott failed and led to another. The first brought two children; the second, three more.

Later in life, after an early 1970s career in nursing, Thelma Jean returned to entertainment. The new gig was the blues. She sang it at nightclubs on the Mississippi Gulf coast, which had become a gambling mecca. Her first husband had been stationed there, as was her second.

This was a partial fulfillment of Bergen's plan. He had seen her ultimate potential, not in films or radio, but as a female ventriloquist in "high-class" clubs.

As in her earliest days performing across the South with her father's medicine show, she thrived with a live audience. "I can follow the audience's reactions when they're sitting there in front of me," she told a reporter in 1947.

Thelma Jean reached age eighty-three before her death on April 10, 2011, in Gulfport. Her family had grown to include seven grandchildren and thirteen great-grandchildren.

Her Nashville years included both the lowest point of her childhood—neglected by her father and sometimes starving—and the highest, when Bergen came along.

How did she look back on the city from her seventy-six-year-old vantage point? "People there were wonderful to me," she said, "just really good people."

WRITER O. HENRY'S
SECRET NASHVILLE VISITS

O. Henry wrote this story about Nashville…"Municipal Report"…the best thing he ever wrote…William Sidney Porter was born Sept. 11, 1862, in Greensboro, N.C., and was only 47 when he died in 1910. In 1884, he moved to Austin, Texas, and got married. Their first child died, but the second, Margaret, lived a full life.

In Austin, Porter was a teller in "an astonishing bank run with astonishing laxity"…He lost his job, moved to Houston and worked as a reporter for a few years. When federal authorities finally ordered him to stand trial for the bank irregularities in Austin, he fled to Honduras.

Two years later he returned to Houston to be with his dying wife…was… convicted…and served more than three years in prison in Columbus, Ohio. Supposedly it was here that he began to write, taking the name of a prison guard, Orrin Henry…

Supposedly, Porter did not want anyone to know his Margaret [attending Nashville's Belmont College] was the daughter of an ex-convict…He slipped into

Nashville…(and) one day was discovered by the Little Old Ladies Literary Society, or some such. They were all atwitter to find the renowned writer was here, and nothing would do them but he attend one of their teas. So he did…or is it just a myth?
—Bill Pryor, Nashville, Tennessee

The first appearance of O. Henry's Nashville story, "Municipal Report," was in *Hampton's* magazine in 1909. The author, whose real name was William Sydney Porter, said that the "whole scheme is to show that an absolutely prosaic and conventional town (such as Nashville) can equal San Francisco, Baghdad or Paris, when it comes to a human story."

This newspaper documented one clandestine Nashville visit by the well-known short story writer, but not until nearly fifty years after it happened. The account appeared in issues of the December 1951 *Nashville Tennessean Magazine*, forty-one years after O. Henry's death.

The author had Tennessee ties to Clarksville, hometown of his wife, Athol Estes, who inspired his best-known story, "A Gift of the Magi." He was also linked to Colesburg, near Dickson, where close friends helped look after his

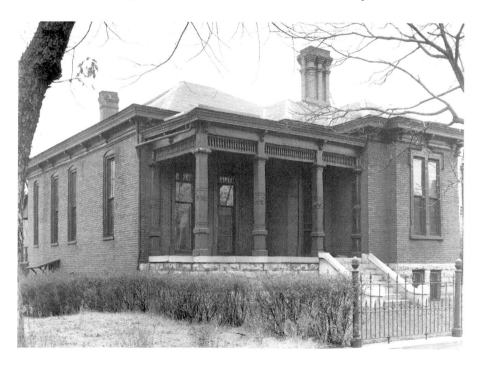

The Nashville house at 1403 Division Street, where short story author O. Henry visited his daughter in 1904, was still standing in this 1951 photo. *The Tennessean file.*

motherless daughter while he was imprisoned, and to Nashville, where the same friends eventually moved.

In addition to his New York City years, he was also associated with Austin, Texas (his daughter's birthplace), and Asheville, North Carolina (a later residence of his second wife and daughter).

Early twentieth-century Nashvillians had been intrigued—and some outraged—for years about the author's "Municipal Report," a fictionalized account of his stay at the Old South's Maxwell House Hotel in downtown Nashville at Fourth and Church.

The reason for his visit was most likely his daughter. While he was anxious to see her, he was also very careful to protect her, at all costs, from knowledge of his embarrassing federal jail term (served from April 25, 1898, to July 24, 1901) for bank embezzlement in Texas of less than $5,000. With that in mind, he avoided public notice while here. This makes it highly unlikely that he agreed to speak to any group, including a ladies' literary society.

The author's daughter, Margaret Porter. *The Tennessean* file.

"Nashville took no notice of his arrival, nor of his departure. There were to be no lectures, banquets or speeches—as legend would have it," H.B. Teeter wrote in his two-part *Nashville Tennessean Magazine* account.

Porter was said to have arrived by train at Union Station in November 1904. He probably did stay at the Maxwell House, as his story recounts, but one midday dinner was taken with his daughter at a red brick residence, 1403 Division Street at Laurel Street.

The site, now occupied by the Best Western Music Row Inn (formerly the Hall of Fame Inn), was in 1904 the home of Porter's cousins, the James A. Boyers family, formerly of Dickson County, Tennessee. The Boyerses sold the house about 1908 to Mary May, whose bachelor son, T.J. May, a meat dealer, was still in residence in 1951 at age seventy-two.

In the last years before its demolition, about 1970, to make room for Music Row development, the house that the writer visited was listed in city directories as the upholstery shop of J. Lawrence Heins, located between two vacant properties.

One significant unanswered question remains. Daughter Margaret Porter may have lived here but doesn't appear to have been attending Belmont College in 1904, the date of the visit cited in this newspaper. Belmont yearbooks show her enrollment at the college for just one year, 1906–07, and then only as a part-time student or "irregular class" member. Her tiny yearbook photo shows her in profile with a fashionable choker ribbon.

Could her father have slipped quietly into Nashville prior to her Belmont year? Could previous accounts of his visit be wrong? Literary historians may continue to wonder.

One thing is certain: O. Henry's observations of Nashville have helped rank "Municipal Report" over the years by both critics and readers as one of his top three short stories.

DISTANT TROUBLES

Outlaws, Slaves and Slums

JESSE AND FRANK JAMES IN NASHVILLE HIDEOUTS

Somewhere I read that the famous outlaws Frank and Jesse James had lived in Nashville at one point in their "careers." Could you verify that and mention where they lived exactly?

—*Mike Mangrum, Franklin, Tennessee*

Several sites in and around Nashville are linked to the notorious brothers whose bank and train robberies have grown into outlaw legends, long capturing the imaginations of Americans. Even an official Davidson County historical marker at 4411 Whites Creek Pike commemorates the James boys' exploits:

> *In this building, then a combination saloon and grocery, W.W. Earthman, magistrate and ex-constable of Davidson County, arrested Bill Ryan, alias Tom Hill, ruthless and indiscreet member of the gang, members of which were in hiding in the neighborhood, March 26, 1881. Frank and Jesse James, meeting nearby, decamped early the next morning.*

It was Ryan's arrest that apparently undermined a year or more of solitude by Frank and Jesse James in the Whites Creek area. The brothers, under the aliases Ben Woodson and Tom Howard, plus their wives and small

This Bordeaux-area house, pictured about 1946, reportedly housed outlaw brothers Jesse and Frank James and their families in the late 1870s and early 1880s. It was demolished in 1977. *The Tennessean file.*

children, shared a hilltop house on a knoll along West Hamilton Road, east of Clarksville Pike, with bachelor farmer Felix Smith.

They helped Smith with farm chores and even brought along "fine race horses"—frequently keeping one saddled for a quick getaway—and a prized cow. Jesse James was said to travel often. His daughter, Mary, was born at the home in 1879. His son was three when they moved in.

"It was with real regret that Smith and the neighbors saw the James families bundle their trunks and beds and stoves into their wagons and drive down the steep hillsides and out to the plains of Missouri," historical writer Louise Davis wrote in a 1946 *Nashville Tennessean* newspaper article.

Bill Ryan got a twenty-five-year prison sentence.

After his return to Missouri, Jesse James was shot and killed by one of his own men who wanted the reward money.

Frank James surrendered and was tried in 1884 in Huntsville, Alabama, for the 1881 robbery of a public works paymaster of $5,200 at Muscle Shoals. He was acquitted and went on to live a quiet life for the next three decades.

The following is a list of the other Nashville venues linked to the outlaws, all in east Nashville:

606 BOSCOBEL STREET: Described as the first Nashville home of Jesse James and his wife, Zee, and the 1875 birthplace of their son. It is no longer standing.

711 FATHERLAND STREET: Said to be the last Tennessee home of Jesse. It still stands.

814 FATHERLAND STREET: Described as the last home of Frank. It is no longer standing.

903 WOODLAND STREET: Mentioned as a home of Jesse in early 1881. It is no longer standing.

The James brothers' escapades, real and imagined, have thoroughly saturated popular culture since not too many years after their affiliation with the Confederate guerrilla raiders of William Quantrill during the Civil War.

Nearly three dozen movies inspired by the brothers began with a 1908 silent film and included two in 1939, one with Roy Rogers and the other starring Henry Fonda as Frank and Tyrone Power as Jesse.

More recently, the 1986 TV film *The Last Days of Frank and Jesse James* featured Nashville's Johnny Cash as Frank, Kris Kristofferson as Jesse and June Carter Cash as their mother.

Kathy Bates was Ma James in the 2001 *American Outlaws*, with Colin Farrell as Jesse. And Brad Pitt played Jesse in the 2007 film *The Assassination of Jesse James by the Coward Robert Ford.*

EIGHTH AVENUE RESERVOIR WASHOUT

I have read in a history book about the reservoir on Eighth Avenue and how it failed in one spot and released a flood on the nearby houses. I believe it happened in 1912. Can you give the history of this beautiful structure?
—*J. Andrew Skipper, Nashville, Tennessee*

My grandparents told me when I was growing up in Nashville and Mt. Juliet the story about the reservoir breaking and washing their house off its foundation. My grandfather told me of people walking into the drained but muddy walls of the old reservoir and also the morbid stories of the fence because women would throw unwanted babies in the old reservoir. Any answers about what happened?
—*Ted Jones, Columbia, South Carolina*

A stone wall of the Eighth Avenue South city water reservoir demonstrates its height. *The Tennessean file.*

Infanticides aren't mentioned in most local accounts of the 1889 reservoir, but they may have occurred. Residents were allowed to stroll or bicycle along its walls until 1917, when the area was closed to the public amid World War I fears that the Germans would try to poison the water. The sudden flood is well documented.

It was just after midnight on Tuesday, November 5, 1912, when Nashvillians living along Eighth Avenue South, near what is now Wedgewood Avenue, heard a horrifying noise.

Before W.O. Arzinger could investigate, he was knocked into his bed by the force of a wall of chilly water. His house at 1504 Eighth Avenue South shook. He snatched up his sleeping wife and headed for a door, just in time to see his residence crash into the one next door and lodge there. He waded out quickly.

"The water was up to my waist, and I was frequently in danger of falling into a deep hole of some kind. I consider our escape miraculous," Arzinger later told a reporter.

T.M. Heffrey of 1502 Eighth Avenue South was swept away, still lying in the floating bed he shared with his wife and child.

"We kept our presence of mind and when the friendly boughs of a tree offered a refuge, we pulled ourselves clear of danger," he recalled.

G.H. Enright lost his henhouse, filled with prize chickens.

When dawn broke, rescue workers found that, quite miraculously, no one had been killed, and there were hardly any injuries. About twenty-five houses were substantially damaged and five were destroyed. Rocks, dead chickens, clothing and furniture littered the streets. At least one cat howled from a treetop refuge. The reservoir wall had a 175-foot-wide V-shaped gap at the top on its east side.

What had happened to bring twenty-five million gallons of water down on everything below the giant holding tank? It apparently wasn't a defect in the reservoir's construction so much as in the natural bedrock that supports a southeastern section of the nearly thirty-four-foot-high walls.

In one spot, the 22.9-foot-wide base of the wall rested on limestone layered with thin slices of clay. Tiny leaks had eroded the clay, compressing the rock strata and causing the heavy wall above it to give way.

The reservoir was completed on August 24, 1889, after exactly two years of construction, at a cost of $364,525. Its elliptical shape runs 603 by 463 feet. An alternate proposed site in Donelson was rejected as too far away. Instead, city leaders selected Kirkpatrick's Hill, former home of the Civil War's Fort Casino, used by Federal troops in the 1864 Battle of Nashville.

Major W.F. Foster, former city engineer, had opposed that location. Foster went so far as to predict the wall's failure in 1897, after he noticed the erosion of rock that had been excavated from the site.

Instead of the national news on that fateful 1912 morning, when Woodrow Wilson had just been elected president, the preoccupation on Nashville streets was the local water disaster.

Fortunately, the reservoir is divided into two halves. The other twenty-five million gallons remained intact and continued to meet the city's water supply needs. A contractor cleaned and repaired the breached half for $70,000.

Some wary south Nashville residents in the neighborhood downhill petitioned to have the whole facility relocated to a less-populated spot. But engineers assured city officials that this wasn't necessary. The repairs would be effective, they said. Concrete was used to fill the hole beneath the break, and fallen stone was returned to the wall.

Nearly one hundred years later, with the reservoir still serving Nashville, the engineers appear to have been right. To boost its longevity and safety, the city did add steel reinforcements to the walls and anchors to the bedrock in 1975–77, along with sensors to detect any slight movement.

SLAVE DEALINGS IN THE CITY

As a student at Middle Tennessee State University, minoring in African American studies, I took a class in Tennessee history and throughout it I noticed pictures indicating that African slaves were sold on Cherry Street in Nashville. If this is so, is there a particular building that these slave auctions took place in? Were there other places in Nashville where slave auctions were held? I feel that it is very important to not only know the major history of Nashville, but also the history that seems to be somehow left covered.
—*Jeremy Simmons, Murfreesboro, Tennessee*

"Slave trading became big business in Nashville and in Tennessee, which was a slave exporting state by 1850," Tennessee State University historian Bobby Lovett wrote in his book *The African-American History of Nashville.* "In that year, eight slave auctioneers operated in Nashville, a slave market second only to Memphis in the state."

Lovett lists several brokers' offices "near the Negro hack drivers' corner" at Cedar and Cherry Streets: Will L. Boyd Jr., 50 North Cherry; Webb,

Merrill and Co., 8 South Market; H.H. Haynes and Co., 16 Cedar; G.H. Hitchings, 72 Broad; Rees W. Porter, 33 Cedar; and Thomas G. James, 18 Cedar. (Cedar is now called Charlotte Avenue, Cherry is Fourth Avenue and Market is Second Avenue.)

A "slave auction block" was on the northwest corner of Lafayette and Lea Streets in south Nashville, and another was on the northeast corner of Cedar and North Cherry.

The 1857 city directory, compiled by the Reverend John P. Campbell, praised the Porter firm, which had bought a full-page ad:

Failure in business, death and the consequent sale and division of negro property, render it necessary that some one should make it his business to seek a master and a home for such as must be sold.

We have known Mr. Porter long and intimately, and can truly say that we have known no one who is more careful of the interests of the slave than he. He allows them an opportunity to choose a master, and often helps them. All persons who may be compelled to sell their negroes would do well to call on Mr. Porter.

Most auctions or sales would probably have been held inside or outside the dealers' offices to allow room for the public gathering of buyers. There doesn't appear to have been a single designated spot because slave trading here was not regularly scheduled.

Slaves, as valuable possessions, were well documented in still existing court and property transfer records that provide a wealth of information. The following are two 1825 entries from a Davidson County deed book:

I, Martha Purkinson, for the natural love & affection I have for my beloved son, Robert S. Tait, give to him a negro woman, named Priss, about thirty six years old.

I have this day sold at public sale the following property of Miles B. Arrington: two negro girls, Nancy & Malinda, one bay mare & colt, one bed, two ploughs & gear, to James Clemmons.

—Wm Ralston, constable.

Vital contributions of slaves to the development of Nashville and other cities have often gone unnoticed.

Even the City of Nashville owned about sixty slaves, put to work to build the first successful water system and maintain the streets. The initial twenty-

A full-page ad in the 1857 Nashville city directory promotes the slave trading of one of the city's largest dealers, Rees W. Porter. *Metro Archives.*

four people, purchased in 1830–31 in Virginia and Maryland, are described in great detail in a bound volume at the Metro Archives called "Agreements, Loans & Slaves."

Several had burn scars listed among identifying characteristics. One named Allen was sold for $350; he was four feet, ten and a half inches tall and fourteen years old, and "his back [was] much scarred with the whip." Anthony, who cost $450 at age twenty-one, was "apt to smile when spoken to." Charles, age seventeen, had all toes on his right foot "injured by being frost bitten." Granville, age fifteen, had "an impediment in his speech."

The city resold some, but not all, after 1833, when they had completed work installing the water system. The same volume listing slaves purchased also details costs of the pipe—bought in 1832 by the city "watering committee"—that city slaves would later install.

Around this time, a few former slaves in Nashville had become economic success stories. One of them, freed by owner Robert F. Woods Sr., was David Woods, who "accumulated a considerable amount of property by his energy and industry." He bought a lot on Front Street (now First Avenue), built a house (sold at auction in 1866 for $2,800) and purchased his own son, Plummer, whom he freed in 1853.

His heirs experienced a series of economic misfortunes but were able to win an 1866 lawsuit. Their family story is preserved in court records now in the Metro Archives.

Slavery was a complex institution, weaving together many economic, social and human elements in bizarre ways. In Nashville many slave owners—and sometimes the slaves themselves—sold their skills and services for pay. In this way, many Nashvillians who couldn't afford to buy slaves, or didn't want the responsibilities, still depended on the slavery system to find workers.

Freedom for slaves in Tennessee did not come until two years after President Abraham Lincoln's 1863 emancipation order, and only after a constitutional amendment was adopted in 1865 by popular vote.

As late as January 1, 1943, Fisk University's ministerial alliance was honoring former slaves still living in Nashville with a dinner at Spruce Street Baptist Church. About a dozen men and women who had been slaves as children remained by that date, just sixty-six years ago.

A FROZEN CUMBERLAND RIVER WALK

I remember that as a youngster I walked across the Cumberland River on ice. This was just above the Woodland Street Bridge. When was that?
—Hillard Brown, Foley, Alabama

You must have been here in 1940, since it's unlikely to have been the previous river freeze of 1905. Temperatures on Friday, January 26, 1940, plunged to six degrees below zero after a snowfall. Schools were cancelled. Less fortunate Nashvillians found it hard to afford heat—at that time from coal—or warm clothes.

A "winter-aid fund" started by the *Nashville Tennessean* newspaper raised more than $500 from donors contributing from $1 to $20. When relief lines swelled at the welfare offices, the city council sought to increase by $5,000 its contribution to the Welfare Commission.

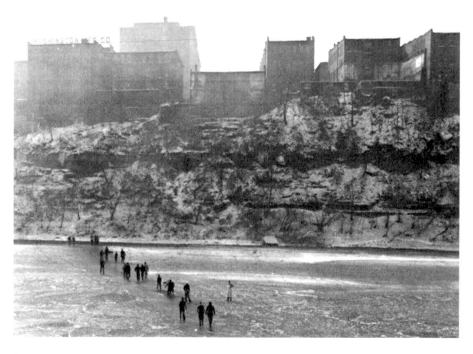

Brave Nashvillians in 1940 walk across the frozen Cumberland River below the building at 222 Second Avenue North that housed Washington Manufacturing. *Walter Storer, Tennessee Historical Society.*

Hume-Fogg High School students donated shoes to help some of the 620 children said to need them. Nashvillians were encouraged to hire those who were out of work for odd jobs to give them a vital but honorable income.

Anyone with sleds, child or adult, took them to the more hilly streets. Police demonstrated tolerance by sending officers to protect prime sledding spots from cars. Police Chief John Griffin recognized that "opportunities for this sport seldom occur in Nashville." However, the pulling of sleds behind cars was banned after a serious accident.

The Cumberland River was still, at that point, a lesser-but-important transportation artery, a decade after the last steamboat traffic had been replaced by the railroads. Ferry crossings remained vital to many in the Nashville area.

At Williams Ferry, upriver from the city, ferryman N.L. Dixon complained of the bitter cold as he thrust a pick to break the ice threatening to jam his paddle wheel. Men at the boat docks in east Nashville used long poles to try to block river ice floes from smashing into boats. Some hulls were breached and swamped anyway.

By that Saturday, adventurous Nashvillians were crossing the Cumberland on foot. The caption beneath a Sunday *Nashville Tennessean* photo showing a line of about a dozen of them read:

> *A bit dangerous perhaps, but these folks can tell their children and grandchildren about when they walked across the ice on the Cumberland—just as history records Nashville's first settlers did to reach the bluffs….Not since 1893 has such a feat been possible, according to the "oldest settlers."*

Records show other freezes of the river in Nashville as February 3–5, 1905; January 13–17, 1893; and December 31, 1876, through January 6, 1877.

In 1893, the steamboat *Rhea* arrived in Nashville on January 15 with ice damage. The day before, Vice President Adlai E. Stevenson had made a chilly visit, during which he had addressed the Tennessee legislature, toured Belle Meade plantation and been the guest at a Hermitage Club banquet.

The first recorded crossing of a frozen Cumberland on foot came after the arrival around Christmas 1779 of founder James Robertson and his party of about two hundred. Some of them reportedly walked the frozen river with their cattle and horses in January 1780, "and immediately went to work to erect for themselves cabins and shanties."

COAL BRINGS A SMOKY CITY HAZE

I am enclosing a picture of the state capitol taken in December 1947 by my husband, Capt. Joe Franklin Turner of Gallatin, the year before we married…He always told me that Nashville used coal as a main source of heat during the 1940s. Could this be the reason the picture is so dark?

—*Annabel Turner, Gallatin, Tennessee*

Nashville's darkest days were much blacker than your photo, even though a smoky haze was probably present when your husband's shutter snapped. Imagine not being able to see the Union Station clock tower from a couple of blocks away in midafternoon. Imagine car headlights appearing as orange blobs from as close as a block distant on a clear-weather morning. That was Nashville's colder months in the 1940s and earlier.

Carbon offsets had not yet been invented, but residents of the city already knew they had too much. In winter, with coal used to heat almost everyone and transport many, "the smoke of its engines and furnaces hangs over the city for months," Donald Davidson, Vanderbilt University Agrarian movement poet, wrote in 1936. "It stops up the lungs, it blackens books, it soils public buildings."

Older Nashville ladies today recall the spare blouses needed when their white collars routinely became blackened from one simple streetcar trip.

The culprit, in particular, was a low-grade coal affordable during America's years of domestic thrift surrounding two world wars. Getting a cleaner-burning supply to Nashville would have included a prohibitive five-hundred-mile transport fee.

Finally, city leaders were pushed by choking residents to do something. They passed an antismoke ordinance in 1941 and began enforcement. St. Louis was used as a model.

By late 1941, a smoke observation tower was in place on a rooftop downtown near the Public Square. Smoke inspectors with binoculars and a telephone would warn any business spewing out too much. After two warnings, a city court appearance was required.

City police officers were enlisted in the crackdown. One politician suggested citizen smoke-watch block captains for each street.

Among those industries cited was the Tennessee Valley Authority for its Nashville power plant with towering smokestacks, then on the downtown riverbank. It burned one thousand tons of coal daily.

Brick manufacturers, railroads and even General Hospital were among others. The city's medical facility escaped punishment when it showed that its only smoky burning came from wet, contaminated bandages from the surgery room.

Some cautioned that without controlling residential stove users, the pollution fight was hopeless. The city's smoke ordinance exempted all single-family residences and small duplexes.

The *Nashville Tennessean* newspaper became involved. It published stinging editorial cartoons featuring "Smoky Joe," an ominous, cigar-chomping character designed to shame city leaders into action.

In the end, cleaner fuel—including natural gas and electricity—became both available and affordable. The city's Smoke Commission lasted from 1941 to 1947.

Scrubbing the blackened evidence of the coal years off downtown buildings took several more decades.

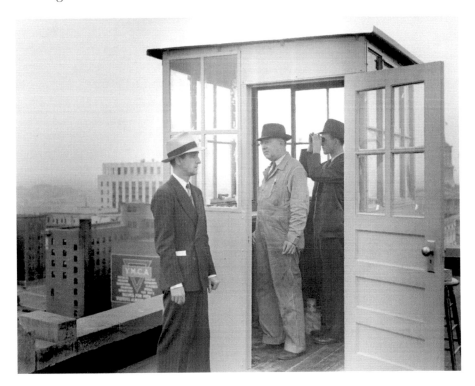

A smoke observation tower to report problems was installed in 1941 atop the Warner Building downtown on the west side of Public Square. *Campbell Bligh,* The Tennessean.

Trains behind Union Station spew smoke into the sky in 1940. *Ed Clark*, The Tennessean.

SLUM LIVING IN CAPITOL SHADOWS

What information or pictures are available about the neighborhood of Shanklin Alley, Pearl Street and Gay Street that was located just below the state Capitol in the sixties? I was a little girl living at 1106B Shanklin Alley—shotgun houses, outdoor toilets, no running water—my old stomping ground. They condemned the neighborhood and everybody had to move somewhere else.

—*Rosemary Johnson, Nashville, Tennessee*

Decaying, rat-infested, pit toilet–lined Shanklin Alley was the shame of Nashville little more than four decades ago. Just west of Capitol Hill and in sight of the majestic seat of state government, the alley and streets nearby were miles apart in their conditions.

Many of its renters were able to pay landlords only from five to twenty-four dollars monthly for an aged, leaky roof overhead. The alley's fifty families lacked running water and hauled it from a single faucet down the street.

A series of newspaper reports in the *Nashville Tennessean* in May 1962 brought attention to the plight of impoverished residents there. Among the

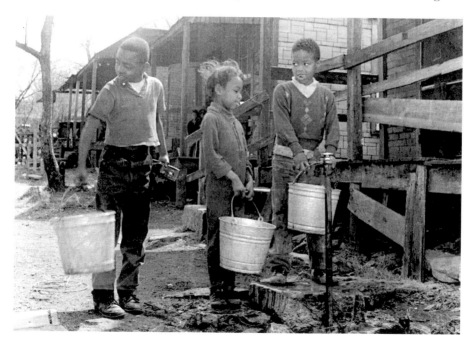

Children line up on Marshall Street near the state capitol in 1967 to get water from the only source for their homes, a single outdoor faucet. *Frank Empson,* The Tennessean.

headlines were: "Shanklin Alley Dirties Shadow of Capitol Hill," "Oldsters Hope Children Escape," "Rot Cleanup Is Major Job."

Lula Black, age seventy-two, depended on friends to carry water for her. At night, she used a kerosene lamp to light a picture of Christ on the wall. The house had no electricity.

Carl Harris, age fifty-seven, who lived there with his ten children, was able to scrimp together university educations for six of them. Two had become teachers, he told a reporter in 1962.

"Someday, when everything else is done, we'll move out of here," he said. He had been a Shanklin Alley resident since 1932.

One little girl who lived nearby, Sandra Faye Daniels, lost two fingers on her left hand to the teeth of a hungry rat.

Shanklin Alley finally fell to a bulldozer in January 1963. Its resourceful rats migrated to Burk's Alley nearby.

The remedy for conditions in the area became part of Nashville's urban renewal movement, a controversial push in its own right. Federal funds helped clear away substandard neighborhoods, but the industrial zoning, freeway construction and street realignments that followed left other residential areas nearby fragmented.

Poor residents of north Nashville found that the program "was much more efficient at tearing down their homes and replacing them with parking lots and high-rise office buildings than it was in providing new housing," historian Don Doyle wrote.

Critics labeled much of the clearance a camouflaged "Negro removal" program because most of those affected were African American.

About 427 families and 279 single residents were removed from the slums on Capitol Hill and immediately west, around what is now James Robertson Parkway and the interstate corridor west of it. New public housing projects housed some of them, but not all could qualify.

NASHVILLE TOGETHER

Prisoners, Paupers and POWs

REMNANT LINGERS FROM STATE'S EARLY PENITENTIARY

After the state prison was located just north of Church Street, and the property was sold and subdivided, the warden's home remained—located at 203 McMillin St. My father, E.J. Roberts, and his father, A.H. Roberts, owned this two-floor structure after the prison moved. Now it still stands…When I bring this up in conversation, I get that look: "Old man, we will let you by with that big lie this time." Can you help?
—*William H. Roberts, Nashville, Tennessee*

Your story is true and resurrects an interesting period of the state's past. Who would believe that a bit of Nashville's 1831 Tennessee State Penitentiary is still with us today? Tennessee State Museum curator James Hoobler, whose book *Cities Under the Gun* pictured Nashville during the Civil War, confirms that the building is authentic to the prison.

It is difficult to imagine now that the state's earliest penitentiary once extended over nearly ten acres in the area between Church Street and Charlotte Avenue from Fifteenth Avenue to the west. The area is now largely filled with shops and small businesses.

Alexander Spears was one of the few people who were probably grateful to be among this new prison's early inmates. Spears, a convicted Winchester horse thief at age twenty-one, was housed within its walls from 1832 to 1837. Had his crime occurred in earlier years, Spears could have been

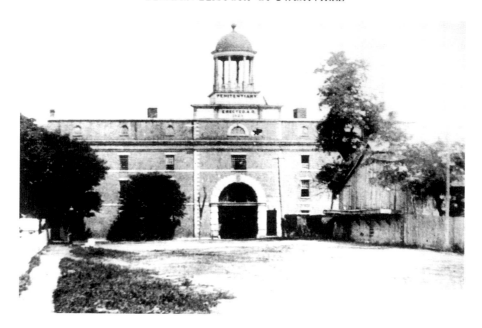

The first Tennessee State Penitentiary (1831–98) extended over nearly ten acres in the area between Church Street and Charlotte Avenue from Fifteenth Avenue to the west. *The Tennessean file.*

hanged at the Franklin County Courthouse Square, a book on early prison records speculates. Earlier Tennesseans didn't tolerate transportation theft. Lawmakers once prescribed death upon first offense.

The state prison helped relieve county governments of the need to house other lawbreakers locally at their own expense.

Nashvillians were so glad the penitentiary was being located in their city, instead of Knoxville, that they raised $2,500 from private sources to buy the land for it. The legislature appropriated $25,000 in 1829 for its construction, but the final cost was double that.

During the Civil War's Federal occupation of Nashville, it was heavily fortified with a stockade to house political prisoners and Confederate traitors. Among them were two upstanding Nashville sisters. Their father was a Confederate colonel. Their brothers died fighting for the Confederacy at the Battle of Shiloh.

"Miss Fannie" Battle, a teacher, was well known. She and her younger sister were accused of smuggling Nashville maps to the Confederate army. They had supposedly observed Federal holdings here during daytime outings and then sketched the details from memory at night. Both were caught and served time first here and later in either Washington or Atlanta—accounts differ—before their release at war's end.

Fannie Battle (1842–1924) is remembered mainly for her work among Nashville's poor. The still operating Fannie Battle Day Home, 911 Shelby Avenue, maintains her legacy.

The prison never lacked a varied inmate population, including learned inmates such as teachers and doctors. Early records show that the top five skills within its first nineteen years were laborers 647 strong, farmers 68, blacksmiths 57 and shoemakers 46. Many were put to work on the grounds in workshops for carpentry, shoe and wagon making and coopering, among others.

Women were imprisoned in a separate section beginning in 1841. One of them, convicted of larceny, listed her occupation as prostitute and was eventually pardoned by Governor James C. Jones.

The youngest early male prisoner was thirteen, convicted of larceny in Warren County. The oldest was eighty, serving a two-year term for arson.

Inmates were vital in providing free labor for construction of the state capitol building. Four prisoners who escaped in 1845 made their break less than two weeks before the capitol's cornerstone was laid on July 4, 1845, and may have been working there at the time.

By 1851, 133 convicts were helping build the capitol—cutting stone, carrying or sawing it and assisting stonecutters.

The prison was viewed early on as a moneymaker that should become self-sufficient. Starting in 1866, the entire inmate population was leased under contract to businesses as cheap labor.

Tradesmen and others protested this inmate competition. When the practice later led to prisoners becoming strike-breaking coal miners in East Tennessee, other miners revolted. Legislators abolished inmate leasing, and it ended in 1896.

A new eight-hundred-cell state prison in Nashville's Cockrill Bend opened in 1898. The castle-like building remained in use until 1992 and has since served the film industry as an occasional movie set.

Boy Scout Founder's Nashville Appearance

As a youngster living in Russellville, Logan County, Ky., from the late 1930s to the mid-1940s, I attended a summer camp called "Camp Cogioba." I think it was

*located in northern Tennessee and run by the Boy Scouts, since I was a member.
When and how did Scouting get its start in Nashville?*
—*Jack R. Williams, Cookeville, Tennessee*

Nashville youths got swept up in the phenomenally popular Boy Scout movement in its very first year in America, 1910. Before two years had passed, Nashville found itself playing host to the British founder of worldwide Boy Scouting, Lieutenant General Sir Robert S.S. Baden-Powell. All did not go well on his visit here. Still, hosting such a distinguished figurehead put Nashville firmly on the international Scouting map early on.

The city's Scout Troop 1 arose from a group of boys who had earlier been loosely joined together in a "Sons of Daniel Boone" club. Their change in allegiance to the spreading Boy Scout movement has been traced to a single day, July 3, 1910. That was the date young Lawrence Hirsig read about the organization in a popular magazine of the era. Hirsig enlisted help from his uncle, Curtis B. Haley, and Nashville's first troop was born, with Haley the first Scoutmaster. The first patrol, the Rams, initially met at Haley's home on Montrose Avenue.

One of the earliest Boy Scout outings was an August 1911 hike that Haley led to the Hermitage, home of President Andrew Jackson, and an overnight camp just outside the gate.

On the second day, the group of seventeen hiked to the nearby Stones River and climbed aboard an abandoned ferryboat they discovered. It capsized when several of the boys rushed to one side to dive off.

Haley, recalling the incident in a 1941 article for the *Nashville Tennessean*, said he realized that six of the boys could not swim. "But some of the Scouts were good swimmers, used their heads and every boy reached the shore safely," he wrote.

Two boys, and Haley himself, were later honored for the rescues with bronze medals in a ceremony at the Ryman Auditorium. President William Howard Taft, honorary president of the American Boy Scouts, made the presentations during a Nashville visit on November 9, 1911.

The following year, Baden-Powell came here on part of an American tour. A Nashville "jamboree" for Scouts to exhibit their skills was held in his honor, also at the Ryman.

When his train pulled into Union Station about 8:00 a.m. on February 23, 1912, the region's two hundred Scouts greeted him. Troops came from Clarksville, Franklin and Bell Buckle, Tennessee, where Webb School was a sponsor. The mayor and Governor Ben W. Hooper were present.

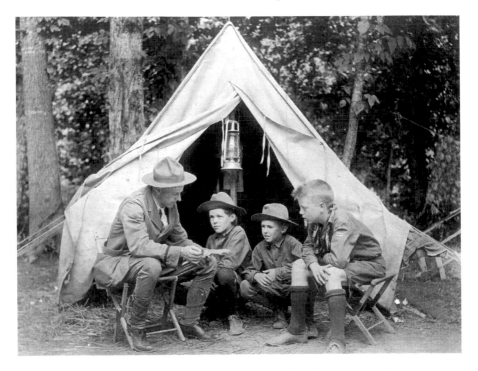

This campsite scene of a Scoutmaster and his Scouts is the oldest surviving photo in possession of Nashville Scouting officials, close to the program's 1910 start. *Middle Tennessee Council, Boy Scouts of America.*

Baden-Powell was having a rough period, though. His fifty-fifth birthday had been the day before. He had just met his wife-to-be on the Atlantic crossing. He was weary from two months of travel and appearances. A morning of ceremony wasn't his cup of tea, so he slipped out the rear of the train and made a hasty retreat to his room at the Hermitage Hotel.

There was some question about whether he would keep his schedule later that day, but he showed up on time for a midafternoon assembly in his honor at the Ryman. Smoke inside the building from the Boy Scouts' demonstration fires irritated the eyes of the audience.

That night, Baden-Powell addressed another gathering, "thrilling the crowd with anecdotes and illustrations of his experiences, always humorous and serious at the same time," historians of the occasion wrote. A slide show of "stereoptican views" was followed by "moving pictures…of the different activities of the Boy Scouts," including how one patrol helped identify and arrest some smugglers.

Still feeling too much pressure for more socializing, Baden-Powell, at another point, "escaped via the luggage lift" to flee the Hermitage, he wrote

in his daily diary. This, unfortunately, was about when the governor, the local Boy Scout committee and a band came to entertain him in the evening at the hotel.

Scouting in Nashville has traditionally sought to include various minority groups, both racial and religious. A Nashville troop for African American boys was formed in 1938 under sponsorship of banker J.C. Napier and others, leading to several more. Jewish Scout troops have also been very active in Nashville under the sponsorship of synagogues. The city's Christian churches were troop sponsors from the start.

Nashville's Troop 1, now relocated to Brentwood, has not had many Scoutmasters. When Haley retired in 1935, he was followed by William J. (Billy Jim) Vaughn, who remained active until his death at age ninety-seven in 2009.

Baden-Powell, who died in 1941, had been disappointed on his 1912 tour to see that the American version of his movement relied from the start on paid professionals to run it, instead of altruistic volunteers as in England. It seems undeniable now that the American model gave Scouting here a stability it might have otherwise lacked.

POOR ASYLUM TAKES PAUPERS, LUNATICS

I have a photograph of the 1915 home of Joel Madison Shacklett with a notation that it was formerly the county farm. Is there any other information about it? He was married to Elizabeth Minerva Nolen Shacklett. I think Nolensville was named for these Nolens.
—Bettye Shacklett, Nashville, Tennessee

Davidson County's farm was known variously as Home for the Poor, Poor Asylum, Asylum for the Poor and Insane and County Poor Asylum Farm. Whatever the name, the institution, which operated on 113 acres in what is now Inglewood, was an innovation for care in Davidson County. Recognizing the need to help those unable to carry on by themselves, county leaders established Davidson County's first poorhouse about 1830.

The county's "pauper lunatics were confined in the common jail at first," but later were "admitted to the state asylum until a separate department could be established by the county," historian W.W. Clayton wrote in 1880. His account provided a rare glimpse into a topic not often discussed.

County officials probably still recalled with a tinge of shame the 1847 Nashville visit of national mental health reformer Dorothea Dix, who came

to examine the state's treatment of the mentally ill. Dix found many of Tennessee's "unfortunates in almshouses [for the poor] where, if violent, their 'frenzied ravings' disturbed the other inmates, or if 'blasphemous and unruly' their presence was 'demoralizing' and 'dangerous,'" said a 1944 article on "Care of the Insane" in the *Tennessee Historical Quarterly*.

The first Davidson County "institution" for the aged, infirm and mentally ill operated from 1864 to 1879 on another site, the farm of Thomas Harris, who served as its "keeper."

In April 1874, the county bought two tracts east of Gallatin Road for $13,000 to serve as a farm residence for those in need, both the indigent and the mentally ill. The farms had previously belonged to the estate of Thomas L. Bransford (1804–1865), a merchant and railroad official, and to Charlotte P. Ramsey. The area was then about three and a half miles outside the city of Nashville.

The facility cost roughly $14,000 annually to operate, but those of its residents able to do farm work on the property helped offset "a large portion" of that through the county's sale of farm products, Clayton wrote.

Three two-story buildings were built adjacent to one another, and a fourth was later added for a superintendent's residence, enclosing a sort of yard.

A three-member commission saw to the facility's operation. By 1880, Isaac W. Lanier was the appointed superintendent, with his wife overseeing its "female department."

The facility housed about 150 to 190 people, roughly half of them African American. The 1880 census listed all of them with the term "pauper." The county physician saw to their medical needs.

"This is not known as a poor house, and it stands so high in the estimation of the citizens that it is considered no dishonor to be permitted to hire keeping there when disabled by age or infirmity," Clayton's history said.

Bordeaux Long-Term Care, Metro Nashville's current 419-bed nursing home on 121 acres northwest of downtown, began in 1893 as the successor to the poor farm. It provided various medical services to residents at Bordeaux Hospital until 1967, when its focus became long-term care.

As for the Shacklett home from 1915, none of the buildings in an 1890s photo of the asylum appear to match it. However, it is possible that the house was another residence on one of the two tracts assembled for the county farm. County deed book maps of the boundaries do not show the structures.

The area is now a residential section at Shelton Avenue off Gallatin Pike. The street name came from the county's 1895 sale of the farm for $15,000

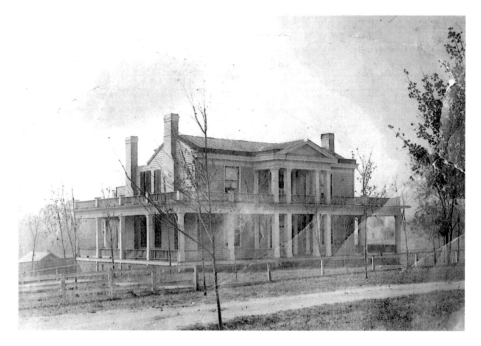

This large brick house pictured in 1915 may have been linked to Davidson County's Poor Asylum Farm. It was once on Shelton Avenue off Gallatin Pike. *Courtesy of Bettye Shacklett.*

to three brothers—P.A., C.F. and E.P. Shelton. By the time of the sale, the county had acquired other land on Hydes Ferry Road to serve as a relocation site for the farm.

PRESBYTERIANS' LONG STAY ON CHURCH STREET

Could you please tell me about the history and architecture of the beautiful church at Fifth Avenue and Church Street? I have admired it since attending school in Nashville in the mid-1940s.

—Martha Frazier, Lawrenceburg, Tennessee

Downtown Presbyterian Church, as it is now known, has been the city's most architecturally seductive house of worship since its opening in 1851.

Designed with exotic Egyptian detailing by a world-class architect, and later colorfully decorated inside with an eye-popping Egyptian style, the church has long set itself apart visually. Today, it is a National Historic Landmark.

"The place is so fascinating it moves people when they see the inside for the first time," said Pat McGeachy, retired pastor.

With the boldness of decor within its walls, it is perhaps no wonder that one of its ministers voiced antiwar and pro–racial rights sentiments just as World War II was escalating in 1941. He was ousted the next year.

Conflict had already visited the church. Wounded Civil War soldiers were nursed there in its role as a makeshift military hospital.

Thousands of World War II soldiers in the area for training maneuvers later camped in the church on weekends when better accommodations ran short in the city. A 1944 newspaper photo showed some curled up on the bare wooden floor of a Sunday school rostrum after all cots were filled.

Architect William Strickland, in the city to design the state capitol, was persuaded by local Presbyterians to replace their church on the same site after it burned down in 1848. He selected details of an Egyptian style made popular after the French emperor Napoleon's military exploits in that country.

The original gray interior was embellished in the early 1880s by craftsmen, who fashioned brightly striped frescoes, lotus blossoms and ceiling rectangles full of painted clouds. Also added outside were two tall columns flanking the front entrance.

The ousted minister from the 1940s, former New York seminarian Dr. Thomas C. Barr, went on to head the city's newly organized Trinity Presbyterian Church. It was one of seven new Nashville-area churches spun off in various ways from the one at Fifth and Church.

The most dramatic break was the 1955 formation of

A Presbyterian church has worshiped on the corner of Fifth Avenue North and Church Street since at least 1816. This 1954 view shows the twin-spire 1851 building. *Bill Preston*, The Tennessean.

Downtown Presbyterian itself from the original First Presbyterian Church as that parent church relocated to Oak Hill. The congregation had debated since 1944 a proposed move to the suburbs, away from various downtown problems and closer to its members' residential areas.

The Strickland building only narrowly escaped being razed for a parking lot because of the efforts of a determined faction of members. They rallied to raise about $550,000, bought the unique church and kept it as a house of worship.

Today, the pealing of its giant bell, the gift of an influential Nashville woman, reminds Nashvillians of their heritage. Its far-reaching sound doubled as a fire alarm in the late 1800s.

Wealthy businesswoman Adelicia Acklen presented the bell as a $3,000 gift to her church in 1867, perhaps with a bit of an ulterior motive.

"She wanted to hear it rung 15 minutes before church time so she could make sure she got there from her mansion where the Belmont University campus now sits," said McGeachy, who retired in 1994 after eighteen years as pastor of Downtown Presbyterian.

Modern-day traffic obviously didn't get in the way of the horses pulling this lady's speedy carriage.

GERMAN POWs HELP WITH WARTIME CHORES

For 40 years beginning about 1920, the J.B. Henderson family lived on a 508-acre farm that lay a mile along the Cumberland River, including Nashville's Cornelia Fort Airpark. In the summer during World War II, we had German prisoners of war who were brought in to work on the farm.

As a little girl then, I remember my mother seeing to it that enormous midday meals were served to them. Apparently they came from Camp Forrest in Tullahoma, Tenn. It was all very secret.

I have searched in the Tennessee State Archives and found only one newspaper article on this subject. What information is available?

—Ceacy Henderson Hailey, Nashville, Tennessee

Davidson County's farmers and others in the mid-state welcomed the help they got from the Germans and Italians held in Middle Tennessee's three

prisoner of war camps. With "our boys" fighting abroad, harvest time could be a struggle here in an era when farming was a more prominent occupation.

The European "guests" produced some strange and sometimes humorous stories for the locals. Consider the following *Tennessean* headlines of the day: "Ex-City Policeman Takes Three Escaped Nazis Here," "Nazi P.W. Is Captured on City Bus," "Italian Internees in Tennessee...Drop Fascist Salute" and "German Prisoners, Quietly and Without Protest, Helping Harvest Crops in Kentucky, Tennessee."

In Nashville, a five-acre section of Centennial Park along Twenty-third Avenue North was fenced off and developed for secure wartime military use. It served, in part, as a "brig" for holding troublesome American soldiers. It also was likely used as a way station for at least some POWs arriving here by train for transfer to POW camps at Camp Campbell (now Fort Campbell in Montgomery County and into Kentucky), Crossville and Camp Forrest near Tullahoma.

Little appears to have been published about that use at the time, but military secrecy may have prevailed. A former *Tennessean* photographer with wartime military service talked about it later.

Nearly 400,000 German POWs, not including Italians or others, were held at POW camps scattered across the United States after being captured in Europe and North Africa. Camp Campbell alone had 2,497 POWs—1,814 of them German—by late 1944, more than a year after it began taking POWs on a ninety-six-degree summer day, July 24, 1943.

In May 1943, the federal government had decided to begin using prisoners of war to help on American farms, in groups of ten or more. The government got two dollars a day per worker, and the POW, in turn, got a government coupon good for eighty cents at his camp's commissary. In Crossville, POWs could even use that to buy 3.2 percent alcohol beer. At Campbell, the rules were stricter, and such beverages were prohibited. The Crossville camp Germans even posted a picture of Adolph Hitler on the mess hall wall.

Campbell internees were allowed to build their own 250-seat theatre, complete with orchestra pit, for dramatic productions. They formed two complete orchestras, viewed German language newspapers and movies provided for them and played ping-pong and chess.

The POWs helped Tennessee farmers harvest and process tobacco, hay, onions and corn. They also grew crops in their own camps. At Campbell, the sixty-eight-acre plot produced enough food to save the government $9,441 in just one year.

German prisoners of war held at Crossville in 1945 make bread from wheat and rye for the POW camp's use. *John Malone, The Tennessean.*

Some of the Germans were talented bakers and were allowed to put that skill to good use. Others had chef experience and were able to keep their fellow POWs well fed. A few even assisted with military dentistry.

Campbell required its POWs to wear a blue uniform, with the orange letters "P" and "W" stenciled prominently. In Crossville, with its greater laxity, soldiers could wear their own German military uniforms if they chose.

Some prisoners coped with the heat of Tennessee summers by wearing shorts. Many whiled away their spare time by organizing soccer teams, with officers playing enlistees and Germans playing Italians in vigorous games.

"Germans believe in keeping in top physical condition, and the strenuous farm labor enables them to keep muscles hard and sinewy," *Tennessean* reporter Jack Setters wrote after a 1943 trip to Camp Campbell.

One prisoner there even got married in absentia through a "proxy" ceremony, uniting him long distance with his childhood sweetheart in Germany.

WATKINS INSTITUTE GOES MODERN WITH FILMMAKERS

My mother had a friend who attended Watkins College of Art and Design in Nashville in the early 1950s. When Norris Gibbs died in California, he left a picture to my son titled "Uncle Tom's Cabin." It was damaged, supposedly by a fire while it was displayed in the college. Can you supply any information?
—*Annie Hepler, Franklin, Tennessee*

No major fires are mentioned in most reports of the old Watkins Institute, a fixture on Church Street for many years. Maybe readers will know if a small blaze ever broke out that could have damaged some of the students' artworks.

Watkins itself—still here today in a new location—is one of Nashville's educational assets that, for this city, rivals the famous Cooper Union in New York, also still active. In fact, the 1859 school there was an inspiration for the 1885 one here. Both were intended to provide training and opportunity to young people who otherwise might have been left behind. Both were founded by hard-luck individuals who, despite their lack of schooling, still became capitalist successes. The founders each used their riches to help others, even decades after their deaths.

In New York, it was industrialist Peter Cooper. In Nashville, it was Samuel Watkins. An orphan, Watkins managed to amass a fortune after starting out as a brick maker. (His product is still visible in Downtown Presbyterian Church.) He worked his way into fields including real estate, railroad, streetcar, telephone and natural gas. His quarry supplied stone for the state capitol. His investment helped bring about Hillsboro Road, extending into Williamson County.

A childless bachelor, Watkins decided that his best legacy was aiding Nashville's children forced by their circumstances to work during the day. He drafted a plan for a night school to give them a chance for advancement. Best of all, tuition was free. It remained that way until 1958.

As the school developed, adults also took part in classes to learn artistic skills, sewing, public speaking and a wide variety of other subjects, even aeronautics. Watkins's wishes were that the areas of instruction be free to evolve with needs of the day.

From 1940 to 1953, Nashvillians would gather in the school's second-floor auditorium to hear lectures and debates by national and local experts on issues of the day. The popular "Let's Think" forum was founded by its

The original 1882 building of the Watkins Institute was on the corner of Sixth Avenue and Church Street, now the left side of the downtown public library. *Bill Preston*, The Tennessean.

moderator, lawyer and civic leader Will R. Manier Jr. (1885–1953), and cosponsored by Watkins Institute and the *Nashville Tennessean* newspaper.

The current Watkins College estimates that more than 350,000 people have directly benefited from the school's long existence, marking 124 years in 2009.

The first two buildings were at the corner of Sixth Avenue and Church Street, now the location of the present Nashville Public Library. The initial Watkins structure also housed the early Howard Library for Nashville,

predating the current public library, which traces its history back to the Carnegie Library of 1904. The two ultimately merged.

Samuel Watkins donated the land in the heart of the city's commercial district for the original school, the location of his own former mansion. Construction with funding from his 1880 bequest of $100,000 began in 1882. His plan called for the Church Street frontage to be leased to shops, with that income helping support the school in the rest of the building.

Another benefactor soon became equally important to the success of Watkins—Ann E. Webber. The German-American had several failed marriages, so she spent many evenings at Watkins observing the help it gave to immigrants adjusting to life in America.

She started a business selling stylish ladies' hats and eventually named the school as a beneficiary of valuable properties she owned on Fifth Avenue North, housing a Woolworth's and the Strand Theatre. The outcome was challenged in court by her relatives, but Watkins won.

The old Watkins building, with its distinctive gothic tower and 1882 date stone, was demolished in 1957, but a new building went up the next year. The ground floor was a W.T. Grant store, with the school in most of the rest.

In 1994, Watkins became a college and added degrees. A special 1998 act of the legislature allowed sale and demolition of the Church Street building.

After a temporary home starting in 1999 on Powell Avenue across from 100 Oaks shopping center, Watkins College of Art, Design & Film had a 2002 ribbon-cutting on the present thirteen-acre home in a former movie theatre complex at Fountain Square in MetroCenter.

Watkins is still governed, as it was from the start, by three commissioners whose appointment requires confirmation by the state legislature. Its traditional strength had long been in its art department, but these days the filmmaking instruction is getting much popular attention, as is the interior design section.

BRIGGS INFIRMARY AMONG EARLY HOSPITALS

What can you tell me about the Briggs Infirmary? My great-grandmother was a patient there in 1901. Enclosed is a picture from the letter she sent home to my great-grandfather.

—*Jean Inman, Hermitage, Tennessee*

The Briggs family of physicians inspired such confidence in Nashvillians that one young Belle Meade lady had no hesitation about checking into their new infirmary. She was a patient, accompanied there by her mother, for about three months.

After her discharge, Dr. William T. Briggs's orders for her continuing home treatment included quarantine with "absolute rest, doses of cod-liver oil, glasses of beer and the application of six leeches every other day." This was Nashville medicine at its best in early 1892.

The patient was Eunice Jackson (1871–1901), eldest daughter of Belle Meade Plantation owner General William Hicks Jackson. She had been experiencing severe depression and later fainting spells, according to a history of Belle Meade by Ridley Wills II.

Dr. Briggs's "private surgical infirmary" did not open until 1891, in a joint venture with the eldest of his physician sons, but his name was already well known in Nashville medical circles.

William Thompson Briggs, whose own physician father had begun his medical instruction at age seventeen, moved here in 1852 from his native Bowling Green, Kentucky. In Nashville, he joined the newly formed medical department of the University of Nashville as an instructor in anatomy.

Excelling in surgery, he was described by one biographer as mastering incisions that were "marvels of nicety…No plunging, hacking or tearing

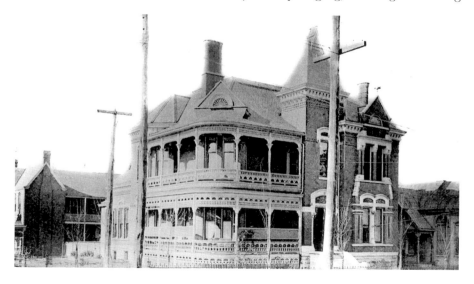

Briggs Infirmary was once located on what is now Third Avenue South at Peabody Street, near the current Howard School complex of city offices. The Tennessean *file*.

ever disfigures his patients…but his strokes are as delicate as the pencil of an artist."

Briggs became a pioneer in gynecological surgery, credited with removing sixty ovarian tumors, some weighing close to one hundred pounds. He was said to have owned the largest library of medical/surgical literature in the South. In 1885, he helped found the American Surgical Association, becoming its first president.

By 1890, Nashville's medical reputation had helped attract the national convention of the American Medical Association (AMA). At that Nashville meeting, with its $1 million worth of exhibits, the estimated eleven hundred participants elected Briggs as AMA president.

His oldest son, Charles S. Briggs, born in 1851, followed in his father and grandfather's footsteps. He graduated from the University of Nashville's medical school in 1875 and launched a career that included lecturing both there and, later, at Vanderbilt University.

After his father's death in 1894, Charles Briggs enlisted his brother, Nashville surgeon Samuel S. Briggs, in the operation of the infirmary. The complex included a "female department" at 421 Third Avenue South and a "male annex" behind it, fronting on Peabody Street.

The Briggs brothers continued the facility until Charles developed pneumonia and died about a month later, in March 1920, at age sixty-nine. He was buried in Mount Olivet Cemetery. Samuel continued with his surgical practice, but the infirmary closed.

By then, Nashville had a variety of medical institutions to care for its citizens. Among the listings in the 1916 city directory were Barr's Infirmary on Nineteenth Avenue South; Douglas Infirmary, at Second Avenue South and Peabody; Fort's Private Infirmary at 209 Seventh Avenue South; and various hospitals including Vanderbilt, Hubbard, St. Thomas, Woman's, Shofner, Nashville City, Galloway Memorial and Trinity.

Also listed were the City View and Cedarcroft sanitariums. Cedarcroft, relocated in 1914 from Lebanon to a ten-acre Nashville site, specialized in "drug, alcohol and tobacco addictions," as well as "nervous diseases." "Our treatment for Whisky Habit is not a Sobering-up Process, but a CURE which eradicates the Disease and Desire for Whisky," its full-page advertisement claimed.

OUT ON THE TOWN

Eating, Shopping and Celebrating

CROSS KEYS RESTAURANT DRAWS DINERS, PROTESTERS

My parents used to take me to the Cross Keys Restaurant when I was growing up in Hendersonville. I think it was located in downtown Nashville and had very good food. How long was it there and when was it closed?
 —*C. Reese, Tullahoma, Tennessee*

The Cross Keys closed in 1978 after a thirty-six-year period of providing Nashville diners with some of the city's best food of those times. It was popular with legislators, businessmen and out-of-towners and was convenient to all with its location at 221 Sixth Avenue North, within sight of the state capitol.

Dishes served there, including shrimp arnaud, hot brown and wilted spinach salad, are recalled fondly in Nashville culinary circles. Even the breads and pies were made in its own kitchen. But the Cross Keys entered local history accounts for two things other than its fine cuisine: liquor and civil rights for African Americans.

The first alcohol by the glass legally dispensed to the Nashville public since before World War I was served at the Cross Keys on November 16, 1967. Don Dickerson, age thirty-two, downed a scotch and soda, paying eighty-four cents for it.

Dickerson had ordered from a brand-new "cocktail menu," with prices ranging up to $1.25. Within a short time that same day, drinks were also

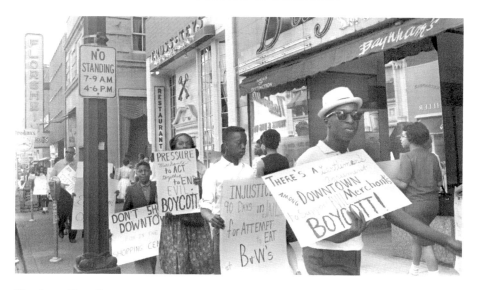

The Cross Keys Restaurant sign is visible at a 1963 civil rights demonstration led by students against racial segregation in eating establishments. *Jimmy Ellis*, The Tennessean.

being dispensed to Nashvillians at the Brass Rail Stables, 233½ Printers Alley; the Belle Meade Country Club; Kinnard's Restaurant, 2200 Hillsboro Road; and the Continental Inns, 303 Interstate Drive.

These five places were the first licensed after Nashville voters, in a September 28 referendum that year, finally approved liquor sales in restaurants for the first time since before Prohibition.

Original rules outlawed sales on Christmas, Thanksgiving or election days until one hour after the polls closed, as well as before 1:00 p.m. on Sundays. Also banned were "B-girl activities," such as employees sitting with customers or accepting drinks from them.

The Cross Keys' owner, John G. Chiles Jr. (1903–1980), personally sold that first drink. Chiles was a restaurateur who came here from Louisville, Kentucky, and opened the restaurant with partner Ray Iverlett in 1942. Chiles's daughter, former Metro council member Betty Nixon, recalled that her father had to limit operations to six days a week because of food rationing in those early days during World War II.

The restaurant also gained a footnote in local history in 1963, when Nashville's blacks were holding demonstrations in the third year of a successful push to end racial segregation of eating places and other commercial venues.

The Cross Keys was not alone as a target for sit-in activists and marches in that period. The B&W Cafeteria, Krystal, the Tic-Toc Restaurant,

various lunch counters and the Hermitage and Andrew Jackson Hotels were among others.

On May 8, 1963, student demonstrators scuffled with a few hecklers outside the Cross Keys. Nine people were arrested after an estimated seven hundred African American students from elementary through college age marched that day from First Baptist Church to several businesses downtown.

Nashville mayor Ben West had said publicly in April 1960 that he felt segregation should end. Mayor Beverly Briley, in spring 1963, set up a biracial agency to work on solving racial problems. By 1964, the year the federal Civil Rights Act went into effect, virtually all of the city's businesses and public places were open to all.

Tinsley's, One of City's Shopping Paradises

What was the history of Tinsley's department store? It was located on Church Street in the 1950s. My father, Charles Tinsley, who died in 1992 at age 91, told me it was started by some of his family.

—Cathy Tinsley Oats, Plano, Texas

Merle Davis of McKendree Towers in Hermitage, who shopped there herself, remembered Tinsley's as one of Nashville's best sources in its day for ladies' ready-to-wear clothing. "I think they dressed a number of the leading people of Nashville, the Cheeks (of Cheekwood) and others," Davis recalled.

Her late husband helped run it in the days before she married him. He told her of buying trips he had made to Europe to help find interesting merchandise.

Castner-Knott, Harvey's and Cain Sloan come to mind for many Nashvillians as the big-name stores when Church Street was at its height of retail popularity. But Tinsley's at the southwest corner of Seventh Avenue—its building is still there—was also popular in its own way.

News accounts say that it was the first Nashville store to install air conditioning and "electric-eye doors" that would open automatically. In 1954, Tinsley's had seventy employees in its ready-to-wear, millinery, shoe and accessory departments, plus the beauty salon.

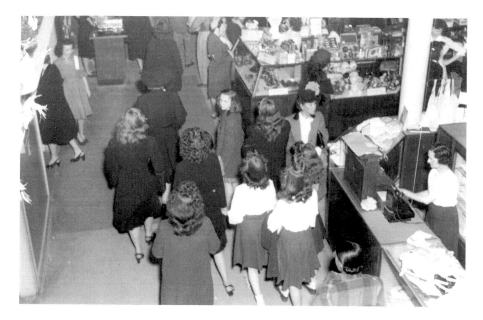

Nashville shopping, shown before Easter 1947, was in department stores like this, with glass display cases for the merchandise. Most were on Church Street. *Eldred Reaney, The Tennessean.*

In 1930, it billed itself in an ad as "a woman's treasure house of chic fashions," meeting "the exacting demands of those who seek finer things" and at the same time satisfying "those with a keen sense of economy."

The store's story goes back to 1888 and—through four downtown locations—forward to 1960, when it became part of an out-of-state chain.

Ellis F. Tinsley arrived in Nashville about 1887 and was working as a salesman on Broadway. The next year, the city directory shows that his brother, Phillip J. Tinsley, joined him. By then, the two, along with widow Mattie A. Tinsley, most likely their mother, were living at 710 Woodland Street in east Nashville.

Tinsley Brothers and Gilbert was their business in 1888. Located at 200–202 Broadway, the shop sold dry goods, boots and shoes. The other partner, William J. Gilbert, lived a couple of blocks away from the Tinsleys at 501 Woodland Street.

By 1894, Tinsley & Gilbert was specializing in wholesale millinery and notions and had moved to 207–209 Broadway. Brother Phillip Tinsley appears to have taken over the business since the name later became P.J. Tinsley Millinery Co.

The Tinsley family sold out around the turn of the century. In 1905, the name was the same but the business had moved to 322 Union Street, with

William H. Jetton as president, Frank J. Beck and George F. Craig as vice-presidents and Joseph D. Partlow as secretary-treasurer.

Other operators included O.D. Kirk and F.B. Strond as president and vice-president in 1930. By that year, the location was its final one, 701 Church Street, where it was relocated about 1925. In July 1954, two managers at competitor Harvey's got bank financing and bought Tinsley's for an estimated $200,000. The store's annual gross sales at the time were estimated at $1 million.

By the time it was resold in 1960 to Hart Stores Inc. of Mobile, Alabama, Tinsley's 51.5 percent majority was owned by Melville Morris with the local Jacob Jewelry Co. Hart owned and operated more than twenty stores in the South, but Tinsley's didn't last.

Hart stockholders were told in 1961 that restoring Tinsley's to its previous stature in the Nashville clothing market wouldn't be worth the risk.

The 13,500-square-foot building had been vacant for many months in 1964 when it became home to the Gold & Silver Co., wholesalers and retailers of diamonds, watches, jewelry, silver and other items—much like the former Service Merchandise Corp.

Edwin Warner (1870–1945) once owned the four-story structure that housed Tinsley's. His name, and his brother Percy's, are reflected in Nashville's Warner Parks.

FRED HARVEY BRINGS CHRISTMAS TO CENTENNIAL PARK

When we were children in the 1960s, our favorite holiday tradition was a visit to Centennial Park to see the Christmas display. The trip from Lewisburg to Nashville was so exciting for us—just filled with bright lights, Christmas carols and a stop at the Krystal burger restaurant where we always ate a sackful! Could you furnish some information about the display? I remember it was composed of white statuettes and was placed beside the Parthenon.

—Pat Hanson, Lynnville, Tennessee

It just wouldn't have been Christmas, Nashvillians and thousands of Middle Tennesseans of a certain age know, without a family visit to the dazzling spectacle that was the nativity scene at the Parthenon. Missing the display at Centennial Park was unthinkable for hundreds of thousands of people each late November to January from 1953 to 1967. The assemblage of biblical

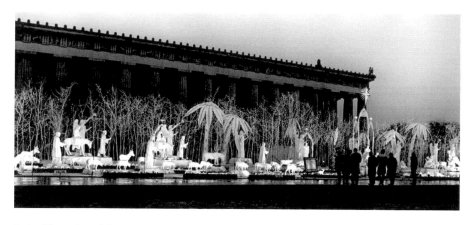

In its fifteenth and final season in 1967, the Harvey's nativity scene at Centennial Park sparkled majestically. Unknown to spectators, the figures were weakened beyond repair. *Dale Ernsberger, The Tennessean.*

personages, angels, animals, sand dunes and palm trees in an exotic setting started out huge and grew as new elements were added yearly.

About seventy-five hundred colorful light globes and a background described in a newspaper report as thirty-three thousand "specially made Italian lights that blink like stars" added to the mystique. All was bathed in brilliant white light—at least until changing colors were introduced in 1955—against a backdrop of the Parthenon's classical Greek architecture. "Silent Night" and other songs of the season blared from loudspeakers from 8:00 a.m. to 11:00 p.m. as spectators drove or walked past.

Fred Harvey (1898–1960), the Canadian-born founder of the now gone Nashville-based Harvey's department store chain, had the inspiration for this gift to the city of Nashville. It cost his business up to $250,000 over the years, in a period when that amount bought a lot more than today's ordinary house. No sum could have purchased the public goodwill, and annual publicity, it created just in time for the prime retail season.

Some eventually accused the scene of being overly kitschy or lacking in artistic merit, but as a reflection of its era, it was universally welcomed throughout the region as uniquely Nashville.

Harvey got the idea for his display in 1950. He heard of a permanent nativity scene near Innsbruck, Austria. On a European tour, he drove miles off the beaten track in the Alps to be inspired by it.

Planning took two years. Italian sculptor Guido Rebbeccini, a graduate of art school at the University of Florence, was chosen to create the figures in the display. He was said at the time to be best known for his life-size figure

frieze in Montreal's Notre Dame Cathedral, as well as works in Bolivia and Argentina. In the late 1950s, he made a six-foot bust of Thomas A. Edison, the electrical genius.

Rebbeccini had help with the nativity scene from Marian Jaulaski, described as his Polish student. Their work—in the medium of alabaster-white celastic (a plastic-impregnated fabric) and hard rubber—was completed at Sylvestri Art Manufacturing Co. in Chicago.

In 1963, a heavy snowfall covered the scene that stretched the length of the Parthenon. The snow added to its beauty but also allowed additional moisture to seep into the statues, which included forty-five humans and seventy-five animals.

Several of the figures were "fiberglassed" in 1964 "to add to their usefulness." The effort wasn't quite enough. Some began to rot from the inside.

By 1968, the annual exposure to Nashville's fluctuating winter weather had weakened and eroded the statuary so much that the diorama wasn't fit to display outdoors. Some of its twelve-foot-high angels were even being described as hazards if a strong wind were to catch their wings.

The display was sold by the city to an advertising agency, which placed it in a Cincinnati shopping center, where it was reportedly used for only two seasons before being discarded as irreparably worn out. It lives on today in the memory of thousands of Tennesseans, as well as on postcards, photos and art prints created over the years.

OPRYLAND AND ITS GREAT FLOOD

I remember the Cumberland River flooding in the mid-1970s. When was it exactly? I was a teenager working at Opryland. It flooded and we had to scrape river mud from the merchandise stores and the park walkways. I had never seen water flowing from the Old Hickory Dam so high and turbulent. The 2004 tsunami in Asia reminded me of the disaster that hit Middle Tennessee in the '70s.

—Mark Evetts, Alexandria, Virginia

The 1975 flood put lower parts of the former Opryland amusement park under sixteen feet of water and shocked Nashville as news of it spread. The water crept to within seventeen inches of portions of the main floor of the Grand Ole Opry House, then only a year old. Pumps frantically pushed 21,600 gallons an hour out of work areas and the tunnel beneath the Opry building.

It was March 14, 1975, just days before the 1972 park's scheduled March 29 opening for its fourth season. More than two and a half inches of rain earlier

The sixteen-foot depth of floodwaters in parts of Opryland in 1975 was evident at the Rudy's Farm Sausage Kitchen, where only the roof remained visible. *Gerald Holly, The Tennessean.*

that week had gradually pushed the Cumberland River over protective dikes, through the park and its parking lots and even over nearby Briley Parkway.

There were a few fatalities. The park's petting zoo lost two wolves, five goats, six rabbits, thirteen quail and a few bantam chickens. The bison and deer were taken to a higher field, while some chimpanzees were sent to board at the homes of Opryland employees. The baby elephant was moved to the Opry House prop room.

Newspaper readers on March 16 saw a strange sight in the photo of Grand Ole Opry general manager E.W. (Bud) Wendell and William C. Weaver Jr., board chairman of the park's owner, National Life & Accident Insurance Co., touring the park grounds together. They were in a small motorboat near the flooded Folk Music Theatre.

Opry legend Roy Acuff visited the park on March 19 to survey the music hall named for him where his relics were on display. He was upset to find an "extremely valuable organ" damaged.

Flood damage estimates for the park overall were placed at roughly $5 million. Its initial construction cost had been about $28 million.

Just two weeks before the flood, Opryland officials had announced a $2.5 million expansion project to add nine new buildings, a new theme area and a "major ride attraction" on seven additional acres. After the damage, there

were questions about whether the park could even open by summer. But a massive cleanup got it back in shape by April 19, when an estimated ten thousand people flocked in for the first day of the season.

Earlier, on March 28, a parking lot tent sale of flood-damaged park merchandise and souvenirs had attracted more than six thousand bargain-hunters. Some items—like the one-dollar record albums—were caked with dried mud, while others seemed untouched by little more than dampness.

"From the time we opened it was like the Oklahoma land rush," Ed Stone, Opryland public relations director, told a *Tennessean* reporter.

The Grand Ole Opry performance was moved for one weekend to Municipal Auditorium, even though the Opry House interior was undamaged by floodwaters. The Ryman Auditorium downtown had not been restored by then, so it could not be used.

What had caused the flood? The U.S. Army Corps of Engineers' Jim Bates blamed "deliberate invasions of flood plains by developers and those who finance developments." Bates noted in a 1975 interview that the then new MetroCenter did not flood, while Opryland did, because "one built an adequate flood wall, but the other did not."

The Opryland area's flood dike has since been enhanced. The park closed after the 1997 season for demolition and construction of the $200 million Opry Mills shopping center, opened in 2000. The site plan for the shopping center called for 800,000 cubic yards of dirt to be hauled in, even as the Corps of Engineers was proposing in 1998 to raise the Cumberland's projected one-hundred-year flood plain by about two feet.

VENDOME THEATRE'S POSH VENUE UP IN FLAMES

What can you tell us about the old Loew's Vendome Theater on Church Street? I remember going there several times as a child to see a movie, and I remember it being either damaged or destroyed by a fire before the former Church Street Centre (now the site of the public library) was built.

—*Tom Nichol, Fairview, Tennessee*

The well-known comedy team the Marx Brothers appeared at the Vendome Theatre in the 1930s. So did Sarah Bernhardt in 1912, Lillian Russell in 1907 and famed actor Edwin Booth, brother of Abraham Lincoln assassin John Wilkes Booth, in 1888.

"A perfect gem, the prettiest and finest theater in the South," opera singer Emma Abbott called it when she performed in *Il Trovatore* for the Vendome's October 3, 1887 opening. "And the acoustics—well, this is perfect."

With a sixteen-hundred-seat capacity and sixteen private boxes, it also featured steam heat, electricity and an elevator, Martha Ingram noted in her book about Nashville's performing arts. The theatre's fancy drop curtain had views of the Place Vendome in Paris.

Abbott's Nashville visit included some surprises. She attended nearby McKendree Methodist Church, still on Church Street today, for a Sunday service, only to face the minister's heated thirty-minute condemnation of theatres and those associated with them, Ingram wrote.

At the end, Abbott could be silent no longer. She rose to "denounce as false and unchristian what has just been said." The congregation applauded after the minister replied: "I shall not undertake to answer the lady, because she *is* a lady."

To top it all, Abbott suddenly found herself singing solo for the closing hymn, with no help from churchgoers intent on hearing only her.

The Vendome went on to play host to theatre, music—including composer Victor Herbert in 1897—and finally, in the 1920s, vaudeville and motion pictures under the Loews chain. Loews' long-term lease in the Vendome Building at 615 Church Street would not have expired until about 1999 had it not been for the unfortunate fire.

The movie playing that night was *The Dirty Dozen*, starring Lee Marvin and Ernest Borgnine. Several people during the last showing on August 8, 1967, complained to management of a smell like burning

Daylight from the collapsed roof shows off fancy patron boxes inside the Vendome Theatre as fireman Marion Claiborne surveys the smoldering 1967 ruin. *Frank Empson*, The Tennessean.

rubber. A thorough search, which included the projection room and second-floor balcony, turned up nothing.

The last patron left the building about 12:15 a.m. Two hours later, a janitor blowing trash to the front of the auditorium heard an explosion above.

"There wasn't any smoke at first," Robert Hargrove told a reporter. "I went around to the stairs and saw the blaze coming out from underneath the second floor balcony."

Flames spread to the roof, which collapsed before firefighters could bring the fire under control. Heavy smoke kept them out of the lobby entrance until about 5:30 a.m.

The ornate theatre's eighty-year run was over. News of the fire was reported by Larry Brinton, then with the *Nashville Banner* and later a local television commentator, and Frank Sutherland, then a reporter and later editor of *The Tennessean*.

Movies scheduled for the Vendome were switched to the Loews Melrose on Eighth Avenue South.

The theatre auditorium was later demolished. Over the decades, its entrance lobby building had housed the Russell Stover Candy Co., Sam Small Jewelry Co. and First American National Bank among non-theatre tenants.

Church Street Centre shopping mall opened on the cleared site in 1989, and the city's downtown main public library replaced that in 2001.

Moving Nashvillians

Train, Plane and Ferry

Union Station Once a Travel, Shipping Hub

When the Korean War started, I went in the Army Jan. 8, 1952, and left Union Station on what I thought to be one of the last trains to depart from there. But I'm not sure. When did they stop?

—Carl W. Eli, Nashville, Tennessee

The period of your trip was a time of dramatic reductions in passenger rail service for Nashville. But it didn't disappear entirely until twenty-seven years later, with the last train of Amtrak's Floridian, connecting Chicago to Miami through Nashville and Birmingham, Alabama.

Nashville once had more than two dozen passenger trains daily in and out of a bustling Union Station. During the peak of preparations for the twentieth-century world wars, as many as fifteen thousand military recruits assembled there daily for rail trips to induction and training centers.

By 1952, the Louisville and Nashville Railroad (L&N)—which had achieved a monopoly on Nashville passenger service—was petitioning the government more and more for approval of route eliminations. Automobile ownership was mushrooming, and rail ridership was no longer as profitable.

In August 1952, L&N sought to discontinue service on trains 1 and 2 between Nashville and the Tennessee-Kentucky state line near Mitchellville in Sumner County. Also requested was elimination of

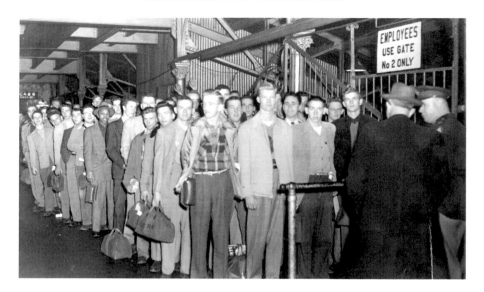

A group of air force enlistees lines up at Nashville's Union Station in January 1951 to board a train. All in this group were volunteers. *Eldred Reaney, The Tennessean.*

trains 7 and 8 between Nashville and the Tennessee-Alabama line near Prospect, Tennessee, in Giles County.

In September, General Dwight D. Eisenhower was aboard a campaign train on L&N lines seeking the presidency. He won. But the same month, L&N asked for federal approval to end routes between Nashville and both Birmingham and Cincinnati. The Ohio–Tennessee train was called the Azalean, a reference to the flowering azalea of the South.

At least in January 1952, train riders here were able to catch what turned out to be one of the last glimpses of the original statue of the winged god Mercury high atop Union Station's tower. It tumbled from its lofty perch in a thirty-five-mile-per-hour spring wind gust the morning of March 22, 1952. The $1,500 figure had been there since the station opened on September 3, 1900. Earlier, it had graced the commerce building for the 1897 Tennessee Centennial Exposition in what is now Centennial Park.

At first, L&N officials indicated that they might restore the sixteen-foot-tall, hollow copper statue. It was lighted in 1939 and had become something of a Nashville symbol. Nashvillian Baxter James Hodge won $500 for designing it.

Ultimately, the railroad decided that the cost factor was too much, with an estimated restoration cost of $4,000. The original was melted down and cast into two tablets—honoring the Goodlettsville Lamb and Wool Club of 1877 and a former University of Tennessee president—both installed in 1955 at the Tennessee Agriculture Hall of Fame in Nashville.

A flat Mercury likeness, there today, replaced the original in recent years after Union Station's transformation into a hotel.

As for the Floridian, Nashville's last passenger train, it has not been so fortunate. By its final years, passengers checked in through Union Station's old baggage building to the east, now converted into offices and restaurants. L&N had basically neglected the station—and more importantly, its roof—deeming it too expensive to repair.

The last Floridian passed through Nashville on October 8, 1979. The route would have ended a week earlier, but a federal court decision forced Amtrak to keep it alive despite losses.

Supporters of rail travel—including then U.S. representative Albert Gore Jr.—saw a glimmer of hope for an Amtrak revival with a spike in gasoline prices in the late 1970s. But Americans so far have remained wedded to their personal vehicles and the airlines.

BERRY FIELD BOOSTS NASHVILLIANS SKYWARD

During World War II, Berry Field was the location of a significant number of military personnel. To house them, a fairly large residential complex was built. After the war, this area was converted into a temporary civilian housing complex to provide homes for returning soldiers. Berry Field was even integrated somewhat, a rare phenomenon in the late 1940s. What ever happened to this development? And do you know if any photos of this residential area exist?

—Tom Pugh, former Nashvillian, Houston, Texas

The fiftieth anniversary of the removal of the barracks buildings from the city's airport complex came in 2003. The step was inevitable as the airport grew from a modest Berry Field into a larger one and finally into Nashville International. Kept during that growth was the airport's old abbreviation, "BNA." The letters still stand for **B**erry Field **NA**shville and have been in use since December 1948. They were the Civil Aeronautics Administration's call letters of the control tower transmitter and were formerly "BRR"—although it's not clear whether that stood for anything.

The 105 World War II–era buildings built by the army at the field formed quite a complex in their day. They cost American taxpayers an estimated $3

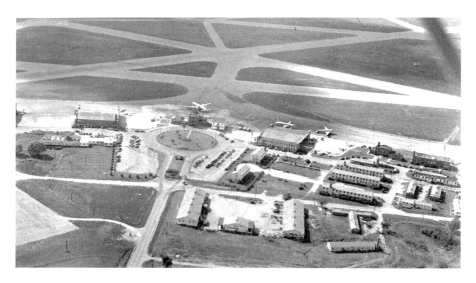

Nashville's Berry Field in about 1948 still had most of the World War II buildings added for its role as a military ferrying base. *Metro Archives.*

million. Several of them were quarters for "Ferrying Command" personnel—nearly 250 strong—who helped fly American-made aircraft direct to Britain and the Allies. Aerial photos from the late 1940s show at least 17 large frame buildings that appear to have been barracks.

By July 1946, only months after the war ended, nine buildings had been converted into civilian housing units for twenty-seven families. Others, used in wartime for what was nicknamed, tongue-in-cheek, the "Berry Field Biltmore Hotel," were being proposed that same year for conversion into overnight hotel rooms for airline passengers.

The federal government's acquisition of Berry Field for the military at the outbreak of war is something of a story in itself. City leaders agreed to lease it for a token one dollar per year to support the defense effort.

After the war, the city had to apply some pressure to get the site returned intact. It was pointed out at the time that other less patriotic cities had gotten much more for federal leases of their airports. In 1947, the city agreed to pay $1,500 and got to keep all of the federal improvements.

Even before World War II, Berry Field had undergone a big improvement program. In 1941, it was estimated that the city had already spent $350,000, and the federal Works Progress Administration (a 1930s Depression-era jobs creation agency) had spent another $1.75 million on the airport's then 325 acres.

The city issued bonds to acquire much of the site in 1935. The first commercial landing was in 1936. Berry Field opened to the public in 1937, named for Colonel Harry S. Berry, the state WPA administrator.

By 1946, Nashville's airport had 2,200 acres and seven aircraft hangars, with an estimated worth of $12 million. By comparison, New Orleans's airport, Lake Pontchartrain Field, was then 1,360 acres valued at $5 million.

In 1951, Berry Field was a busy place. An eight-hundred-foot runway extension to seven thousand feet to "aid landing of big jet planes" was being proposed for up to $500,000. The U.S. Air Force was using some facilities formerly used by the Tennessee National Guard. The state Air National Guard's 105th Fighter Squadron had its quarters and facilities there. Veterans in the School of Aeronautics were on site.

The Nashville and Tulsa, Oklahoma, airports were being described as the only self-supporting ones in the country. Nashville's city government supplied no funding.

Youth Inc., for a fourth year, was using surplus airport buildings in the summer to house and entertain boys and girls, as well as young visitors from Europe here for the "Hands Across the Sea" program.

In July 1951, it was announced that the airport would be getting a new device known as "radar," reaching thirty miles in all directions. Airplanes would "form 'pips' on the face of the screen" to indicate their positions to controllers.

A September 1952 *Tennessean* report said that former army barracks being used by the Nashville Housing Authority would be torn down "after they are abandoned before next May." The demolition was intended to make way for light industrial and commercial development.

AUTO PIONEER DORRIS, FROM BIKES TO ENGINES

What is known about an automobile manufacturer in Nashville in the early 1900s and what was the company name?

—*Clayton Clouse, Nashville, Tennessee*

Nashville appears to have had several shops experimenting with development of "'horseless carriages" in the late nineteenth and early

Nashville-born automotive pioneer George Preston Dorris, age seventy-two, sits behind the wheel of a 1902 St. Louis model after driving it to Nashville from St. Louis on a two-day trip with his wife in 1946. *John Malone,* The Tennessean.

twentieth centuries. Many present Nashvillians know of the Marathon, since its manufacturing plant at 1305 Clinton Street—now Marathon Village—houses studio and office spaces. They were made here in 1910–14 after the Southern Motor Works operation relocated from Jackson, Tennessee.

With production estimated at up to ten thousand, the Marathon has been described as the only car completely manufactured in Tennessee until arrival of Spring Hill's Saturn plant in 1990.

Another early car with strong Nashville ties, but less well known, was the Dorris. It was actually produced in St. Louis, after being developed here. Inventor George Preston Dorris, age twenty-three, son of a Nashville newspaper editor, fashioned a gasoline-fueled auto in his brother's bicycle shop on Church Street. An 1897 test run to Lebanon and back—the return trip took just three hours—proved its reliability.

Dorris and a friend, John French, had been testing the design since 1895. French's family had a piano factory in St. Louis, where the two formed St. Louis Motor Carriage Co.

The car was first called the St. Louis, basically a copy of the design perfected in the bike shop. One sold in 1898 to a Dallas multimillionaire has been called the first gasoline-powered car in Texas.

In 1901, Dorris patented the float carburetor used on autos for decades afterward. In 1902, he sold sixty-five cars in Boston alone.

His older brother in Nashville, Duncan Dorris, abandoned the bicycle shop in 1905 and formed a dealership, the Nashville Motor Car Co. It soon occupied a new brick building on Ninth Avenue North, with show windows on Church Street.

That same year, Preston Dorris reorganized as Dorris Motor Car Co. to begin a twenty-one-year history of producing the Dorris. The car came in several colors and had an initial price of $2,250, rising to $5,000 for a 1922 luxury model.

Duncan Dorris continued to give his brother in St. Louis advice from Nashville customers for improvements to bring quieter and less smoky cars.

Duncan (1872–1972) also had the dubious distinction of being involved in one of Nashville's first traffic accidents. Traveling at six miles per hour on Broad Street, now Broadway, he struck two ladies at the corner of what is now Twelfth Avenue. Neither was seriously hurt, and a charge of "fast and careless driving" was later dismissed. He continued driving until age ninety-five.

The emphasis on quality materials and assembly—"Built up to a standard, not down to a price" was the slogan—eventually priced the Dorris out of national competition. The last car came in 1926, after an output ranging from 92 to 296 a year.

An intriguing list of other early Nashville car entrepreneurs appeared in a 1990 letter written by Robert Howles, who said he was working on a book about Tennessee automotive history. The project never came to fruition.

Howles listed six he found here: Volunteer Carriage Co., incorporated 1905; Harding Manufacturing Co., incorporated 1899; Hermitage Automobile Co., incorporated 1911; the Cyclette, built and tested in 1904; the McEwen, built 1913 by Norman S. McEwen at 111 Louise Avenue; and Percival C. Cloyd's 1911 autos built at 1110 Third Avenue South.

MARATHON CARS DRIVE NASHVILLE FORWARD

What is the story behind the Marathon Motor Works? It is now Marathon Village on Clinton Street but was the first and only car manufacturing plant in Nashville.
—*Jerry Kornegay, Hermitage, Tennessee*

This 1911 Marathon was manufactured in Nashville and painted a dark green for William Green Denny, whose grocery was on Sixteenth Avenue South near Grand Avenue. *Courtesy of Elizabethine M. Gaultney.*

Before Nissan, before Saturn, even before decent roads linking Nashville's cars to the rest of the state, there was the Marathon. In fact, promoters of this particular newfangled automobile set out to prove that horses weren't necessary anymore. To do it, they took two Marathons from the Hermitage Hotel east as far as Bristol and west to Memphis, both ends of the state. It was a real feat on 1911 roads, even if it took about a week each way.

Governor Ben W. Hooper welcomed the automotive pioneers home from the eastern route.

Consider the obstacles. Among them were mud, streams to cross, more mud, fallen trees, ruts, impossibly steep hills, more ruts. At some points and in certain road conditions, the only passable route for a car in those days was inching precariously across a bumpy railroad trestle.

Unlike most of the state, Nashville was the beneficiary of its central location for road construction. By the 1830s, 410 miles of "macadamized" roads—basically graded and graveled—radiated from the city. But they were built by private turnpike companies and required a toll to use in those horse-and-buggy days.

Decades later, when motorized vehicles emerged, the posts used to block unpaid passage were very real hazards. After dark, the unlighted white-

painted barriers in the middle of the roadway became invisible to many motorists. Ruined radiators, or worse, were common.

The Marathon was born in 1907 in a former Jackson, Tennessee boiler factory known as Southern Motor Works, where about one hundred cars were made. It soon became a Nashville hit after its manufacture was moved to a block-long factory between Twelfth and Thirteenth Avenues North along Clinton Street, active from 1910 to 1914. Roughly six to ten thousand Marathons were manufactured here.

A showroom on Broadway near Twelfth Avenue exhibited the latest models. Of the forty-three cars sold in Nashville in 1911, twenty were Marathons.

Initially, only two models were produced. A management decision to switch to up to twelve body styles at a range of prices may have helped spell doom for the company. It meant competing with other national firms at all price levels—even Cadillac, challenged with Marathon's high-end Champion model. There were also management and ownership changes, with inexperienced leadership emerging.

As the late J.C. Bradford told the late auto enthusiast Tom Shriver, once district attorney here, there was "no one in charge, and no one connected with the enterprise knew anything about making cars."

Louise Davis, whose detailed 1982 article in *The Tennessean* chronicled the rise and fall of the company, noted that some of the prominent Nashville investors lost their homes when the firm went bankrupt in 1914. The plant at Clinton and Twelfth kept manufacturing parts until 1917.

The plant's primary building was an 1881 factory formerly known as the Phoenix Cotton Mills. It still stands today, its date prominent in stone, as part of the complex known as Marathon Village.

The shuttered Marathon factory was languishing in weeds and neglect when urban visionary Barry Lyle Walker recognized its potential and bought it in 1987. Inside the ruin, he discovered left-behind evidence of the Marathon story and launched a quest for one of the actual cars, ending with success in 1990.

Since then, Walker has acquired three more and overseen development of his Marathon Village into a block-long complex of artists' and photographers' studios, residences, offices, a gymnasium and even a beer brewery. Some spaces in the complex are still undergoing renovation, but the effort has already ensured that the Marathon name of Nashville's early automotive fame lives on into the twenty-first century.

HYDE'S FERRY, FROM BOAT TO BRIDGE

Can you tell us about Hyde's Ferry, the dates it operated and the Hyde(s) it is named for? Hartwell Hyde (a brother, I think) built a home near Triune in Williamson County about 1802 which is still owned and occupied by a direct descendant.
—Bob Campbell, Franklin, Tennessee

This early branch of Davidson County's ferry system didn't start with a member of the Hyde family, but Hydes later operated it for decades, so it took their name. It began in 1794, just west of the western end of the present Buchanan Street, in the Bordeaux area of north Nashville. The county's northwest section depended on it.

A July 15 grant that year by the Territory of the United States of America South of the Ohio River awarded the Cumberland River crossing to Joshua Baker near his house, Davidson County court minutes show. Later, it was operated by Thomas Hickman, once a county sheriff, and afterward by Henry Hyde.

Hyde arrived in Nashville in 1800 but died in 1812. Some of his six sons and their offspring helped keep the ferry crossing in the family.

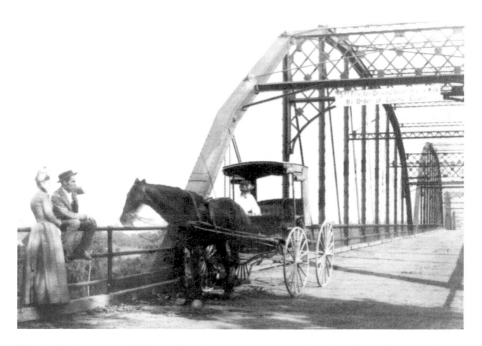

The bridge that replaced Hyde's Ferry in 1891 had signs calling for a five-dollar fine "for driving faster than a walk." *The Tennessean file.*

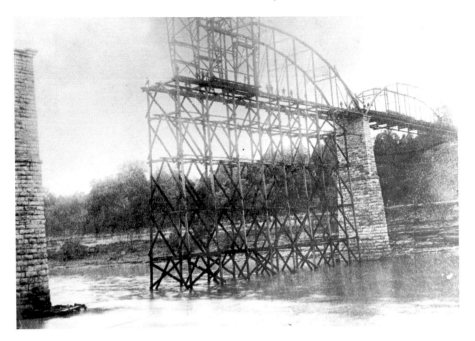

The ferry across the Cumberland River in North Nashville had been in operation since 1794 when this bridge took its place. The Tennessean *file*.

Several problems plagued Hyde's Ferry by the 1880s, making it unpopular with those forced to use it to reach the city. Steep grades down to the crossing mandated light loads for horse or mule teams.

A stockholder-owned toll road was the only approach to it. Toll fees ate up 10 percent of farmers' profits in taking goods to market, one farmer figured. The twenty to thirty cents charged for the turnpike approach to the ferry chewed heavily into the two dollars a farmer might get for his garden produce.

Even worse, the ferry rules of not operating after dark or in windy or high water periods meant users often ended up with expensive Nashville hotel stays when they were unable to go home.

Public pressure prompted the county to authorize a bridge and select a site about halfway between the Hyde's and Buena Vista Ferry crossings. Construction began in 1887, after riverboat Captain Tom Ryman—now of Ryman Auditorium fame—lobbied successfully for a higher span that wouldn't impede vital river traffic. Cost of the bridge grew $20,000 from the original $100,000 when it had to be raised for steamboat traffic.

Turnpike company opposition delayed its use until legal rights to the approaches were established in 1891. Suddenly, land prices tripled on the far bank—just as some had predicted.

This first county-built bridge in Davidson County eventually became a railroad crossing for the Tennessee Central and later the Nashville and Ashland City Railroad. Its sturdy piers still support track today, visible from the M.L. King Jr. Bridge on Clarksville Pike.

Hartwell Hyde, Henry's brother, settled in Williamson County two years after him, arriving from North Carolina in 1802. Hartwell's family had one thousand acres just east of Triune. There they "built a sturdy log house and lived simply but abundantly, never replacing the pioneer dwelling with a more pretentious brick as so many of their neighbors did," says the 1971 book *Historic Williamson County*.

INTERURBAN RAILWAY DELIGHTS COMMUTERS

For years I have had this persistent part-dream, part-memory of a visit to Nashville in the early '20s. I seem to remember riding on a streetcar on tracks and a trip on an interurban to somewhere south of the city toward the Brentwood or Franklin area. Is it possible that this is not a dream?

—*John L. Maddox, Duck River, Tennessee*

Operators of a recent rail line now connecting Nashville with Lebanon are probably still dreaming of duplicating the once-upon-a-time success of the Nashville–Franklin Interurban. This very real electric-powered rail link between the two cities was vastly popular from the start of its regular service in 1909 until its end in 1941 as a victim of the bus.

Conductors in its first days were "policing a mob" and pulling potential passengers off the car roofs, according to one account. "Cars built to carry 50 people pulled out with three times that number," James A. Crutchfield and Robert Holladay wrote in their book *Franklin, Tennessee's Handsomest Town*.

Helping fuel that earliest interest in April 1909 was public curiosity to see recent tornado damage to Franklin buildings, the authors noted. However, the route of nearly seventeen miles never lost money, making $57,000 and carrying 150,000 passengers in 1939 alone.

The individual credited with bringing the rail service into reality was Henry Hunter Mayberry of Franklin. The former Birmingham, Alabama

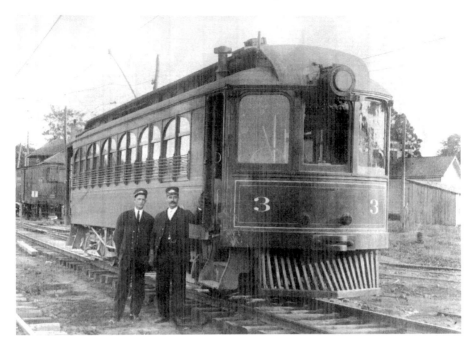

Nashville Interurban Railway Co.'s Car 3 waits in Franklin with its conductor and motorman in this photo from about 1913. *Courtesy of the Hank Sherwood Collection.*

wholesale steel nail magnate, whose family had come from Williamson County, took charge in 1905 of a lagging railway plan launched in 1902 with the sale of $3 million in stock.

Franklin merchants feared a shopper exodus to Nashville if a rail line were in place. But the Franklin newspaper backed the plan, editorially pushing a new role for the city as home for a suburban "tide of population." That proved prophetic as the century progressed.

By the time Mayberry began hiring survey crews for the route—generally along Franklin Pike in Davidson County and Wilson Pike in Williamson County—landowners became so eager for it that they donated almost twelve miles of the total fifty-foot right of way.

Groundbreaking on the Franklin end was in May 1907, with Mayberry's daughter doing the honors. By December of that year, a *Nashville Tennessean* article quoted him as paying out more than $10,000 monthly for the work and predicting a first run for the following July 4 celebrations. In fact, the inaugural car didn't roll until Christmas Eve 1908. Nashville's mayor had put the final spike in the northern end of the track, near Douglas Corner on Eighth Avenue South, just seventy-five days earlier.

The trip cost ten cents each way. The seven-day-a-week service ran hourly, the first car departing Franklin at 6:00 a.m. most days and the last return car leaving at 11:30 p.m., after the Nashville theatres closed.

Among the Nashville stories of the line was the time, in 1921, that a power failure stranded a car as it reached the top of an Eighth Avenue hill. Passengers quickly helped the motorman and conductor jam tools and nearby debris under the heavy car's wheels to hold it in place, according to the *Nashville Tennessean*'s front-page account.

That seemed to work, so the dozen or so passengers settled into their seats to wait for electricity to resume. But in the darkness half an hour later, a passing auto came too close and dislodged the makeshift braking material.

Despite the motorman's attempts to stop the seventeen-ton car, it began to roll toward Nashville, picking up speed for six blocks until crashing a half block south of Division Street into a darkened Glendale line city streetcar, demolishing platforms on both cars.

The motorman jumped back just in time to avoid injury, but four passengers were slightly injured, the worst of them a Franklin man hospitalized for broken ribs and collarbone.

The beginning of the interurban's end came when Nashville's mayor and city council adopted a May 7, 1940 resolution allowing a bus company to take over the city's streetcar routes—numbering twenty or more at one point—and replace them with buses.

With Nashville streetcar tracks becoming obsolete, the interurban had no easy way to get Franklin passengers from the edge of the city at Douglas Corner to downtown. The company was forced to spend $27,000 for three buses. The last interurban ran in November 1941.

The final Nashville city streetcar ran on February 2, 1941. The defunct interurban's cars were shipped to the Atlanta/Marietta, Georgia area, where two of them remained in service until 1947.

Nashville's bus fleet grew from 154 in 1940 before World War II to 246 by 1951, but its electric streetcars and their downtown transfer station on Demonbreun Street were no more.

Downtown rails were either paved over—some still become visible today as potholes develop—or ripped up for scrap metal.

Another interurban also started by Mayberry, known as the Blue Grass Line, ran twenty-nine miles from Nashville to Gallatin from 1913 to 1932. One of its bridges has remained visible in recent years along Gallatin Pike near Kirkland Avenue.

Surviving relics of the Franklin interurban have included two covered stone waiting shelters, one on Franklin Pike near Robertson Academy Road and the other in Brentwood at Meadow Lake Road and Seward Road, just west of Franklin Pike. The Nashville Interurban Railway Co.'s coal-fired power plant in Franklin, dating to 1930, can be seen at what has been recently known as the Factory at Franklin.

Reading List

Armistead, George H. *Art Work of Nashville.* Nashville, TN: Gravure Illustration Co., 1901.

Bergen, Candice. *Knock Wood.* New York: Simon & Schuster, 1984.

Bloom, John. "Assignment America." United Press International, March 4, 2003.

Brandau, Roberta Seawell, ed. *History of Homes and Gardens of Tennessee.* Nashville: Garden Study Club of Nashville and Parthenon Press, 1936.

Caldwell, May Winston, ed. *Beautiful and Historical Homes in and Near Nashville, Tennessee.* Nashville: Brandon Printing Co., ca. 1911.

Clayton, Professor W.W. *History of Davidson County, Tennessee.* Nashville, TN: Charles Elder, Bookseller, facsimile edition, 1880/1971.

Creighton, Wilbur F., and Leland R. Johnson. *Boys Will Be Men, Middle Tennessee Scouting Since 1910.* Nashville: Middle Tennessee Council, Boy Scouts of America, 1983.

———. *Building of Nashville.* Nashville, TN: 1975.

———. *The First Presbyterian Church of Nashville: A Documentary History.* Nashville, TN: Williams Printing Co., 1986.

Crutchfield, James A., and Robert Holladay. *Franklin, Tennessee's Handsomest Town.* Franklin, TN: Hillsboro Press, 1999.

Douglas, Byrd. *Steamboatin' on the Cumberland.* Nashville: Tennessee Book Co., 1961.

Doyle, Don H. *Nashville Since the 1920s.* Knoxville: University of Tennessee Press, 1985.

Fulmer, John. *Sun Herald*, March 26, 1995.

Goodstein, Anita S. *Nashville 1780–1860: From Frontier to City.* Gainesville: University of Florida Press, 1989.

Hoobler, James A. *Cities Under the Gun: Images of Occupied Nashville and Chattanooga.* Nashville, TN: Rutledge Hill Press, 1986.

Ingram, Martha Rivers, with D.B. Kellogg. *Apollo's Struggle, A Performing Arts Odyssey in the Athens of the South, Nashville, Tennessee.* Franklin, TN: Hillsboro Press, 2004.

Jeal, Tim. *The Boy-Man: The Life of Lord Baden-Powell.* New York: William Morrow and Co., 1990.

Johnson, Leland R. *Memphis to Bristol: A Half Century of Highway Construction.* Nashville: Tennessee Road Builders Association, 1978.

———. *The Parks of Nashville.* Nashville, TN: Metropolitan Nashville and Davidson County Board of Parks and Recreation, 1986.

Long, E. Hudson. *O. Henry, The Man and His Work.* New York: Russell & Russell, 1949.

Lovett, Bobby L. *The African-American History of Nashville, Tennessee, 1780–1930.* Fayetteville: University of Arkansas Press, 1999.

Lowry, Thomas P. *The Story the Soldiers Wouldn't Tell: Sex in the Civil War.* Mechanicsburg, PA: Stackpole Books, 1994.

Martin, Mary. *My Heart Belongs.* New York: William Morrow & Co., 1976.

Moore, John Trotwood, and Austin P. Foster. *Tennessee, The Volunteer State: 1769–1923.* Chicago: S.J. Clarke Publishing Co., 1923.

Myers, Frank, and Gennie Myers, eds. *Nashville Fire Department, Then and Now.* Marceline, MO: Walsworth Publishing Co., 1976.

Nashville and Davidson County Public Schools, the Bicentennial Committee. *A Bicentennial Chronicle.* 1976.

Norman, Jack, Sr. *The Nashville I Knew.* Nashville, TN: Rutledge Hill Press, 1984.

Public Library of Nashville and Davidson County. *Send for a Doctor, Paragraphs from Nashville History.* 1975.

Sherrill, Charles, and Tomye Sherrill. *Tennessee Convicts: Early Records of the State Penitentiary.* 1997.

Simbeck, Rob. *Daughter of the Air: The Brief Soaring Life of Cornelia Fort.* New York: Atlantic Monthly Press, 1999.

Summerville, James, ed. *Home Place: A History of the Hillsboro-West End Neighborhood, Nashville, Tennessee.* Nashville, TN: Hillsboro West End Neighborhood Association, 1992.

Wagner, Richard M., and Birdella Wagner. *Curve-side Cars Built by Cincinnati Car Co.* Cincinnati, OH: Wagner Car Co., 1965.

Waller, William, ed. *Nashville in the 1890s.* Nashville, TN: Vanderbilt University Press, 1970.

———. *Nashville 1900 to 1910.* Nashville, TN: Vanderbilt University Press, 1972.

West, Carroll Van, ed. *The Tennessee Encyclopedia of History & Culture.* Nashville: Rutledge Hill Press & Tennessee Historical Society, 1998.

Wills, W. Ridley, II. *History of Belle Meade Mansion, Plantation and Stud.* Nashville, TN: Vanderbilt University Press, 1991.

Woodring, Thomas Volney. *Reminiscences & History, Nashville Fire Department.* 1939.

Yeatman, Ted P. *Frank and Jesse James: The Story Behind the Legend,* Nashville, TN: Cumberland House, 2000.

———. *Jesse James and Bill Ryan at Nashville.* Nashville, TN: Depot Press, 1981.

Zepp, Louise, ed. *The Tennessee Conservationist.* Nashville: Tennessee Department of Environment and Conservation, n.d.

INTERNET REFERENCES

www.allmusic.com
www.belcourt.org
www.ccmusic.com
www.cooper.edu
www.dpchurch.com
www.eoa-architects.com
www.imdb.com
www.malco.com
www.nashlinks.com/remember
www.nashville.gov/Bordeaux
www.obsessedwithwrestling.com
www.oceanwaystudios.com
www.watkins.edu

About the Author

George Zepp is a locally renowned journalist and history researcher in the Nashville area, where he penned the local history column "Learn Nashville." The question-answer feature enjoyed a nearly eight-year run in *The Tennessean* from April 2002 to January 2010. Zepp's career in journalism spanned more than thirty-three years as an editor and reporter in Nashville at *The Tennessean*. In addition to his newspaper work, Zepp has contributed his local history skills to books and special publications on Nashville, his hometown of Clarksville, Tennessee, and his present home of Rugby, Tennessee.